The Modernist Still Life — Photographed

Jean S. Tucker

Exhibition Schedule

University of Missouri-St. Louis, Gallery 210,
February 20-March 17, 1989

University of Missouri-Kansas City, Gallery of Art,
April 21-May 19, 1989

University of Missouri-Columbia, Museum of Art and Archaeology,
June 3-July 2, 1989

Funded by grants from the Missouri Arts Council,
the Regional Arts Commission, and the National Endowment for the Arts.

Published by the University of Missouri-St. Louis
Office of Publications
8001 Natural Bridge Road
St. Louis, Missouri 63121-4499

Printed in the United States of America.
Library of Congress Catalog Card Number: 89-50100
ISBN 0-9601616-6-X

Table of Contents

Acknowledgments . 4

Introduction . 6

Zeke Berman . 12

Clegg & Guttmann . 16

William Clift . 18

Marie Cosindas . 22

Robert Cumming . 24

Jan Groover . 27

Betty Hahn . 29

Barbara Kasten . 31

Frank Majore . 33

Robert Mapplethorpe . 34

Sheila Metzner . 40

Olivia Parker . 42

Irving Penn . 48

Lucas Samaras . 52

Color Plates . 54

Bibliography . 68

Checklist . 69

Acknowledgments

This catalogue and the exhibition accompanying it have been made possible by grants from the National Endowment for the Arts, the Missouri Arts Council and the Regional Arts Commission. On behalf of the University of Missouri-St. Louis and Gallery 210, my appreciation is expressed to them, for without the support of these cultural institutions this project could not have been presented to the public.

In the early stages of the organization of *The Modernist Still Life—Photographed,* several photographic historians made valuable suggestions, including Richard Rudisill, Diana Edkins-Richardson, Susan Kismaric and Beaumont Newhall. I am appreciative of their interest in the project.

Exhibitions of this nature are always joint efforts. From the original conception, a lengthy and often byzantine process ensues involving conspicuous collaboration between many individuals and agencies. This collaboration leads, one hopes, to a catalogue and presentation worthy of the effort.

The following agencies, institutions, and individuals who participated in this collaboration are gratefully acknowledged: colleagues at the University of Missouri for their support and assistance—Dennis Judd, Director of the Center for Metropolitan Studies, exhibition sponsor; Sandy Overton-Springer and John Kalinowski, Center for Metropolitan Studies secretarial staff; Laura Watt, student intern, research assistant; Murry Velasco, Lisa Payne-Naeger, and Lois Engfehr, members of the Graphic Services Department who designed and edited the catalogue; Tom Kochheiser, Director of Gallery 210; Morteza Sajadian, Museum of Art and Archaeology, Columbia; Craig Subler and Pat Darish, Gallery of Art, Kansas City; who supervised all arrangements for the exhibition at the three sites.

My thanks also to the following artists, galleries, museums, and private collectors for their generous loans to the exhibition—The Art Institute of Chicago, Lieberman/Saul Gallery, Holly Solomon Gallery, Castelli Graphics, Pace/MacGill, Brent Sikkima/Vision Gallery, Jay Gorney Modern Art, Andrew Smith Gallery, John Weber Gallery, Robert Miller Gallery, and Nell Gutman, curator for Sheila Metzner. Permission to reproduce the Baron Adolphe de Meyer and Paul Outerbridge photographs was given by the Amon Carter Museum, Ft. Worth, for the Josef Sudek still life by the Jacques Baruch Gallery, that by Charles Sheeler by the Museum

of Modern Art for the Paul Strand by the Paul Strand Archive, Millerton, New York, and for the Edward Weston by the Arizona Board of Regents, Center for Creative Photography.

We take pleasure in noting that *The Modernist Still Life— Photographed* is the inaugural exhibition in a new space for Gallery 210. Since its inception in September 1972, the gallery has in the modest space of a former classroom, handsomely exhibited works of all arts media. It is evidence of the administration's recognition of the importance of Gallery 210 to the cultural life of the campus and the extended community, that larger more commodious space has been designated for the gallery.

I am especially thankful to all the participating artists for their generosity, not only in making their photographs available, but for responding openly to questions about their work through correspondence, telephone conferences, and personal interviews. I am certain I also speak for them when I express my thanks to Thomas Southall, Curator of Photographs, Amon Carter Museum, for delivering the introductory lecture to this exhibition designed to celebrate photography's sesquicentennial year.

JST

Introduction

We are celebrating 150 years of photography. Since the announcement of Daguerre's photographic process in 1839, the camera has been seen as the most reliable instrument for depicting the world as it is. That restricted function was thought by many to be its sole function. Charles Baudelaire was not the only critic who, as early as 1859, was willing to allow photography to be the handmaiden of "factual exactitude" but would not allow it to touch upon the "impalpable and the imaginary, upon anything whose value depends solely upon the addition of something of man's soul." It is true that far more photographers seek to bring to view the world as it is, rather than as it might be or as it is interpreted. The very practical possibilities of the medium make this understandable. Nevertheless, since its inception, photography has been understood by photographers to be capable of more than mere representation.

Perhaps nowhere in photographic images do we see the independence of the photographer from the real world so clearly expressed as in the body of work categorized as still lifes. That the first camera images by Niepce and Daguerre were studio still lifes was a necessity imposed by the technical restrictions of their equipment. By contrast, still lifes conceived by the modernists seen in this exhibition result, not only from the sophisticated camera techniques developed since 1839, but from aesthetic choices made by skillful artists wishing to express relationships not found in natural or urban settings. Although every photograph stills time and motion and could broadly be termed a still life, these pictures have been chosen for their conscious still life arrangements. Hence the limited dictionary explanation of "still life" as small inanimate objects used as subject for a picture, has been made specific here to exclude natural arrangements found in the world. Rather the definition centers on those constructed by the photographers and focuses upon

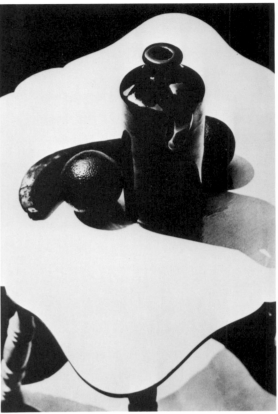

Paul Strand Figure 1
Jug and Fruit, Twin Lakes, Connecticut 1916
© 1976, Aperture Foundation, Inc.,
Paul Strand Archive

contemporary works by living artists who have concentrated an important body of work in the still life genre.

Despite the fact that photography, evolving as it did at the time modernism was being defined in all art forms, was never subjected to the hierarchical restrictions and ranking of subject matter which valued history paintings and images of Man above the still life, the latter genre has not been the most prevalent work of the medium. Of all the increasingly broad and varied bibliography on the subject of photography, we find far more

concentration, outside documentary work, on landscape and portraiture than on the third major art subject category, still life. The photographic still life, from its inception when it constituted the entire, albeit limited, scope of the medium to the present, has received diminished emphasis relative to other photographic subject matter. Yet almost every known photographer has left some still life work. By the mid-nineteenth century a few, such as Fenton, Braun, and Bayard, had concentrated their attention on the genre, leaving rich images based upon a primarily Dutch painting tradition, but reconsidered photographically. As twentieth-century modernism evolves, more significant photographers created still life works of increasing originality. Paul Strand in his

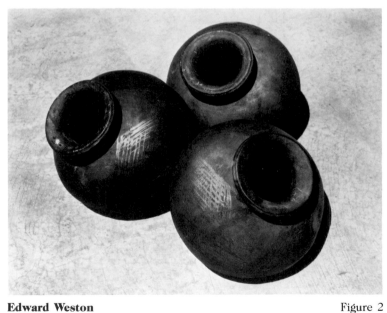

Edward Weston
Tres Ollas de Oaxaca, 1926
© 1981
Arizona Board of Regents
Center for Creative Photography

Figure 2

Jug and Fruit, Twin Lakes, Connecticut, 1916, *(Figure 1)*, seems in this work almost part of the cubist paradigm of that period. Edward Weston's *Tres Ollas de Oaxaca* of 1926, *(Figure 2)*, was a work of such compelling power as to cause René d' Harnoncourt to exclaim that Weston's was the way and the vision, predominant over the painter's.[1] Among others whose interest reached into this area were Josef Sudek *(Figure 3)*, Paul Outerbridge *(Figure 4)*, and Baron Adolphe de Meyer *(Figure 5)*, the latter's flower studies having been featured in *Camera Work*. It is only within the last decade that significant numbers of photographers began to emphasize the still life. The reason is one which may find parallels in the painting tradition.

Van Deren Coke discusses connections between photography and major twentieth-century art movements, dating modern photography from 1915-20 with the geometric compositions of Strand, Sheeler, and others whose new ideas served to separate pictorial photography from modern.[2] Paul Strand stated that "things as simple as that (bowls, chairs, cups and saucers) were my material for making experiments to find out what an abstract photograph might be". In 1915-16 Strand changed to a sharper style of straight photography seen in simple still lifes through a lens stopped down to f/22. When Edward Weston met Strand and Sheeler in 1922, all three found agreement in their belief in the importance of pure, straight unmanipulated images as the proper vehicle for modern expression.

Of all the modern early twentieth-century still life masters whose work inspired but did not determine the varied forms of the contemporary photographs seen in this exhibition, a single image which foretells and describes its organizing concept is Charles Sheeler's *Cactus and Photographer's Lamp*, 1931, Museum of Modern Art, *(Figure 6)*. Here the still life is precisely arranged on a columnar base and positioned to be "taken" under the nearby photographer's lamp. That this

composition inspired a painting as well, raises questions about the relationships between photography and other art forms. For the painting has been restricted to a limited palette of photographic black and white tonalities, and the photograph has extracted details from the real world to present only the essentials of a Precisionist painting. This exhibition purports to define the still life in Sheeler's terms, as one consciously constructed by the photographer to be photographed, and advances the proposition that in both paintings and photographs, the modern still life emerges as an expression of the free choice of the artist, allowing for more personal symbols and more exceptional objects than possible in the traditional "nature morte" arrangements of food, flowers, the hunt, musical instruments, and library accoutrements.

From its symbolic yet secondary role in religious paintings, the still life emerges in the seventeenth century as an independent genre. Meyer Schapiro, in a notable essay in which he explores the meaning of still life through the apples of Cezanne, attributes the evolution of the modern still life to that artist's ability to create mood through his choice of objects.[3] He reminds us that we can distinguish one painter from another, Gris from Leger, Matisse from Picasso, by the objects each has included in his still lifes, revealing to us the style and mood of each artist. So does each of the photographers in this exhibition project and transmit to the viewer a very particular mood and language through his or her choices of what has been assembled by each to be photographed. Yet a recognizable style is infinitely more difficult to achieve in photography than in painting. As John Szarkowski has noted, in photography the photographer "hides his hand," by which is meant that he doesn't have the single distinguishing characteristic of the painter, a personal brush stroke. In 1937, Beaumont Newhall wrote that while the mark of the individual is not left upon the

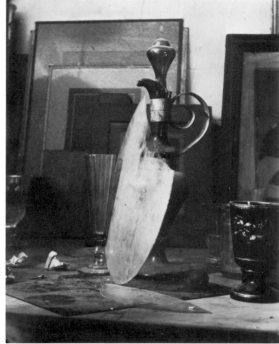

Josef Sudek　　　　　　　　　　　Figure 3
Glass Labyrinth, 1968-70
Jacques Baruch Gallery, Chicago

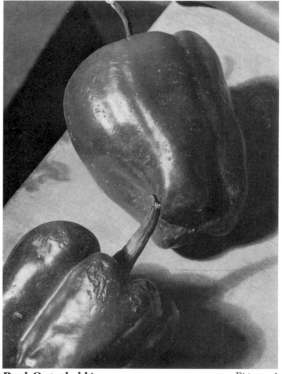

Paul Outerbridge　　　　　　　　Figure 4
Two Peppers, 1923
Amon Carter Museum, Ft. Worth

surface, the photographer asserts his personality by the intensity of his vision. Hence it is remarkable when a photographer evolves a distinct style all his own. The viewer will note how highly individualized is each photographer's work chosen for this exhibition, and how that uniqueness has been largely achieved through the choices of objects comprising the still lifes. No longer must those objects have religious significance as they did in paintings prior to the seventeenth century. Neither need they be objects of value or high significance, but may follow a path blazed by Chardin who has been heralded for humanizing the tradition in his paintings of humble everyday forms, chosen as the objects in these photographs have been, not for their preciosity, but for their geometric shapes and personal associations. There remain those like Schopenhauer who, while praising the Dutch, described their still lifes pejoratively as dealing with "trivial matters" and "insignificant things" to which Edward Weston rejoins that the photographer's concentration upon an object, his choice of it as subject, gives it an importance it would not seem to have and elevates it from the realm of the trivial. The photographer's transformation of a cabbage leaf to a new light abstraction of grace and fluidity and wonder is an aesthetic act created by Weston. So is that of every great artist who renders visible the invisible, who brings to the object through his sensibility more than the thing seen in nature.

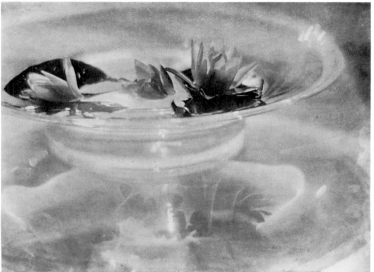

Baron Adolphe de Meyer Figure 5
Still Life, c. 1908
Amon Carter Museum, Ft. Worth

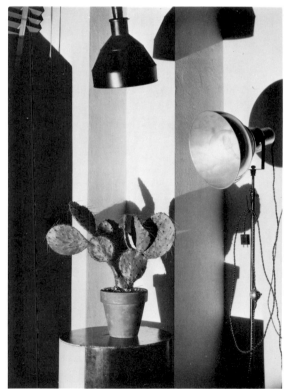

Charles Sheeler Figure 6
Cactus and Photographer's Lamp, 1931
Museum of Modern Art, Gift of Samuel M. Kootz

As Weston asked, "Does it make any difference what subject matter is used to express a feeling toward life?"[4] Surely we are aware in studying the myriad objects of which these modern photographs are composed, how common they are and how little their intrinsic value has to do with the result of what has been accomplished in the finished work.

Nevertheless, we need to go back to Dutch seventeenth-century still life painting to find the beginnings of such a bringing together of unusual objects as we see in these contemporary photographs. Many references to the relationships between Dutch painting and photography have been documented, as in the case with Talbot's own awareness that the genre scenes he photographed at Lacock Abbey for "The Pencil of Nature" were similar to compositions by DeHooch, Vermeer, and Van Ostade. More recently, Carl Chiarenza's essay "On the Aesthetic Relationships Between 17th Century Dutch Painting and 19th Century Photography", asserts that they share a characteristic vision seen in the still life which is time captured and life stilled.[5] We take great pleasure in the degree to which the Dutch painter "fools the eye," in his marked ability to transpose the three-dimensional world of nature to the two-dimensional canvas, recognizing that the camera starts from another point and is not designed to create deception in depicting reality, as did Zeuxis in tricking the bird to believe in the reality of the grapes, but renders instead a more intense objective vision.

If the still life photographed is not intended to fool the eye in its semblance to reality, neither do the objects within it carry the same emotionally charged symbolism of those in the early paintings. Yet, it seems that often in the inventive contemporary arrangements, overtones of the past are brought to mind. Chardin's respected kitchen objects, chosen from his own household, are recalled by Jan Groover's dramatically enlarged close-up forms, tilted so that the tabletop, although implied, has all but disappeared. As Henri Fantin-Latour daily chose flowers from his own garden as his subject and just as scrupulously considered the vase in which to place them, so do Robert Mapplethorpe and Sheila Metzner acquire exquisite vases to be incorporated in their compositions. Hence we realize that the inner eye has begun the photograph even before its components are assembled. Perhaps it is the austere simplicity and order and the juxtaposition of realism and abstraction in Spanish painting, especially in such a work as Cotan's Still Life (1602-05) of which we are reminded by Irving Penn's brilliantly black compositions, combining as they do recognizable and mysteriously unknown forms. That of the past which is associated with Betty Hahn's botanical layouts in life-size Polaroids is the tradition of the botanical print. All these recollections and still others seen in works by these contemporary photographers are not direct quotations but intimations which bring the realization of an ongoing tradition, that of the still life. We may take pleasure in this historic anniversary, knowing that a significant artistic genre continues to be explored.

Jean S. Tucker
Center for Metropolitan Studies
University of Missouri-St. Louis

Notes

1. Nancy Newhall, ed., *The Daybooks of Edward Weston,* vol. I, Mexico, (New York: An Aperture Book, 1973), p. 188.

 August 29. Rene had not yet seen my work—He burst into superlatives, excited gesticulations. "The modern painters are all off. They have chosen the wrong medium to express their ideas—but they would not dare admit so if they saw these photographs. This print *(Three Ollas of Oaxaca)* is the beginning of a new art."

2. Coke, Van Deren with Diana C. Du Pont, *Photography: A Facet of Modernism,* Photographs from the San Francisco Museum of Modern Art, (New York: Hudson Hills Press), in association with the San Francisco Museum of Modern Art, 1986.

3. Schapiro, Meyer, "The Apples of Cezanne: An Essay on the Meaning of Still-life" (1968), in his *Modern Art: 19th and 20th Centuries—Selected Papers,* (New York: Braziller, 1978), pp. 1-45.

4. Nancy Newhall, ed., *The Daybooks of Edward Weston,* vol. II, (California: An Aperture Book, 1961).

5. Chiarenza, Carl, "Notes on Aesthetic Relationships Between 17th Century Dutch Painting and 19th Century Photography," *One Hundred Years of Photographic History,* Essays in Honor of Beaumont Newhall, ed. Van Deren Coke, 1975, pp. 20-31.

Zeke Berman

What this exhibition in its diversity of subject matter makes abundantly clear is the truth of Robert Louis Stevenson's much-quoted observation that "the world is full of a number of things." These artists all draw from the world's storehouse of those found and chosen things and, at times, from fabrications of their own making. Zeke Berman presents to us, from training as a sculptor, some objects we can recognize and others we've never seen before, all in a new and sometimes jarring context, as he works for a "tactility of vision." We are aware that while the technology of making a photograph is scientific, it is the subjectivity of the photographer's inner vision which creates the picture. Works as initially puzzling as these must be examined carefully to determine what his inner vision is expressing.

The earliest, *Untitled,* 1984 (still life with fruit bowl) presents us with the most traditional still life aura—a tabletop arrangement of fruit, a tilting carafe, and just one piece of silverware. But why all this webbing of glue strands? They provide directional and connecting spatial delineations, flatten the picture plane, create visual illusions and ambiguous perspectives. Is this a playful reminiscence of Albrecht Durer's sixteenth-century woodcuts of an artist drawing a lute or a nude, designed to be demonstrations of perspective? The strings leading to a nail on the wall were intended to stand for the line of vision to indicate how the three-dimensional subject is transposed to two on the canvas.

In an October 27, 1988 conversation with the photographer Berman spoke of his increasing interest in the evolution of the brain and the mind, of the importance to the development of his work of a year spent in Florence, and especially of the influence of John White's study of perspective in *The Birth and Rebirth of Pictorial Space,* 1967. His cognizance of the fact that all photographs create the three-dimensional world is seen in these lines leading from front to back, up, down and across, connecting all within the composition, while providing a kind of gossamer linear drawing over the entire picture.

The space is much shallower in *Untitled, 1985* (hoop and canes) which is composed of a different kind of linearity provided by canes vertically hung from a thin eye level board. This serves as the ubiquitous still life tabletop but displays no traditional arrangement, merely a partial hoop. Such synthesizing of elements emphasizes the fact that the photograph is a process of assemblage. Nowhere is this fact more dramatically illustrated than in the still life. Unlike Rauschenberg who makes an assemblage

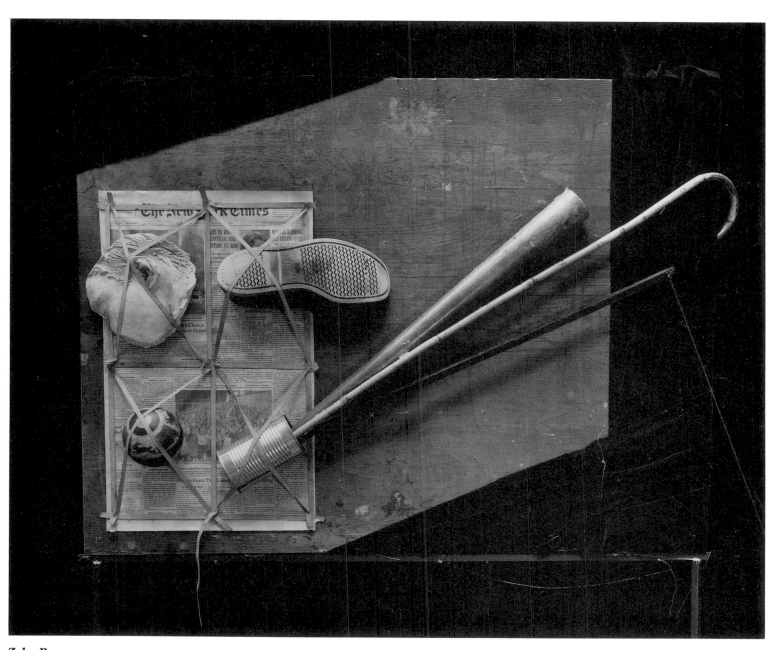

Zeke Berman
Untitled, 1987

of an art work, Berman delights in photographing these unorthodox assembled constructions.

He pays a bit of homage to the element of trompe l'oeil in painted still lifes in his latest work shown here, *Untitled, 1987*. Here a shoe, a child's ball, a portion of a clay profile head, and a tin can holding several jutting stick-like forms are held down by a tape band to a *New York Times* page, all stapled to an odd-shaped, almost rhomboid wooden board which reads like a three-dimensional box in perspective. Of course he knows what Peto and Harnett explored in the late nineteenth century. We may have come full circle when we realize that the sources for Harnett's *After the Hunt*, 1883 (Amon Carter Museum), were the mid-nineteenth century large photographs of game and hunting still lifes by the Alsatian photographer Adolphe Braun, whose work he could have seen on a trip to Europe in 1880. The circle is further widened when we note that Braun's arrangements of hung game and hunting paraphernalia emulated graphic art which had been popular in Northern Europe for 200 years.

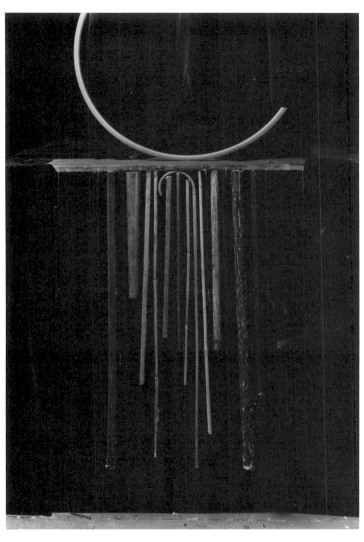

Zeke Berman
Untitled, 1985

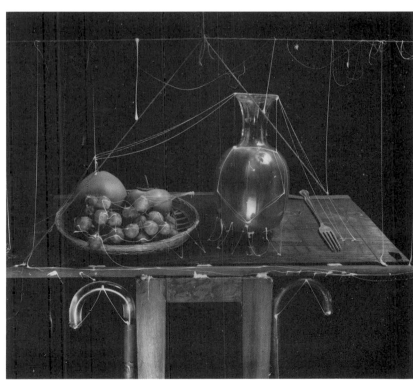

Zeke Berman
Untitled, 1984

Clegg and Guttmann

Color plates
on page 54

Collaboration in the arts is well established from works as diverse as Titian's completion of Bellini's *Feast of the Gods,* 1514, to contemporary designs for public spaces, achieved through efforts of teams consisting of engineers, architects, and artists. But the collaborative process in creating a photograph is more difficult to visualize, for only one hand can "take" the picture. It is in the "making" of the photograph, that is, in its conception, composition, and exposure that the joint participation occurs. In *Collaboration,* a 1988 exhibition featuring the work of Clegg & Guttmann, together with eleven other photographic teams, curators Mark Johnstone and Trissa Miller emphasized that one common characteristic of such work is that most involve performances. Nowhere in photography do we see stronger evidence of the role of the director.

Everything in Michael Clegg and Martin Guttmann's work is directed like a theatrical stage set upon which they have been producing photographic images since 1980. These so-called "tableaux of the good life" have primarily been portraits or still lifes, the two groups having many conceptual features in common. Use of the 4×5 view camera gives the photographers the format to enlarge life-size images, giving a vivacity to each composition. All the works carry traditions of the past, yet bring a modernist assertion which smiles at that very tradition. For example, in one of the group pictures, part of the *Family Portrait Series,* the Bronstein family is posed after Goya's *Holy Family* of 1786. The drama this team achieves in the portraits from use of spotlights, painted and photographed backdrops and settings, the carefully ordered wardrobes of the sitters, and the very poses of those sitters, are details of production management brought to the still lifes as well. We might say they manipulate and compose with the figures as though they were objects. Sometimes the portraits are not commissioned works but are totally fictionalized by Clegg & Guttmann who hire actors as sitters. Ideationally related in their implied criticism of the corporate world, they differ from Hans Haacke's images and texts which present the ironies and power of that world, in that this team focuses upon those foibles in purely visual terms without syntax.

All this choreography is seen in the two still lifes in this exhibition. The photographers speak of "the photo-saturated-lens-culture environment of contemporary life" which they feel calls for "photographic distillations of photography." Much more than photography is distilled in *Sunkist*

Lemons (with a Tea Strainer) seen here. Chardin would be more shocked than the Spaniards at the assertion of scale, vividness of color and intensity of light, all caught and contained within a baroque black satin drapery. Outside the focused central still life arrangement, but an integral part of its meaning, is a somewhat crushed, used envelope revealing a partial address to or from " U. Prinz, on Calle del—, Espan." The palette—yellow, orange, black, and wood tones—conveys the intense contrast of light and shadow of a Mediterranean sun, elements noted by Goya and by Motherwell, and by all who have felt and caught that distinctive light.

In *TABA-BASCO*, so named because those are the exposed letters on the two Tabasco bottles, we see the inclusion of a container of Kiwi polish, a form often used by Clegg & Guttmann, blue teacups, and gold coins. Such a conglomeration of unrelated objects becomes at least partially understandable when we learn that they seek neutral objects which do not have strong media identity, and which are not quaint but modern. They feel that the effectiveness of a still life doesn't depend on any specific iconography, that you don't have to have skulls and hourglasses.

Like other conceptualists of their generation, they bring attention to the uniqueness of the photograph by making only one print of each picture. This forces the audience to value the photograph as seriously as a painting and responds to Benjamin's thesis in *The Work of Art in the Age of Mechanical Reproduction*. They feel that in so doing, the human content is emphasized over the mechanical. They see the still life as the most obvious record of direct experience. By emphasizing the human content of that experience in a single image, they strive for more than is immediately seen in these constructions to include all that is implied—toward a synthesis between past and present conceptions of art.

William Clift

Born in Boston in 1941, William Clift has lived in Santa Fe since 1971 and today carries influences of the two quite opposing geographic areas. The modest, private, aristocratic New Englander shapes his personality as strongly as the weathered countenance and piercing eyes of one who carefully scans the southwestern landscape.

His accomplishments are many as are the honors bestowed on him. He has been the recipient of Fellowships by the Guggenheim Foundation and the National Endowment for the Arts in Photography and was commissioned to make photographic projects by the Massachusetts Council on the Arts, Joseph Seagram and Sons Bicentennial, "The American Court House," American Telephone and Telegraph on "American Images", the Readers' Digest Association to photograph the New York State Capitol and another to document the Hudson River Valley. He has received his state's highest award, the Governor's Award for Excellence and Achievement in the Arts, in New Mexico.

It is not an overstatement to mention that any exhibition of contemporary American photographs, especially those based on landscape, will include Bill Clift's photographs. Equally impressive is the list of books and portfolios exclusively on his work or in which it is included. His latest book is *Certain Places, Photographs by William Clift*, 1987.

Clift's landscapes and architectural photographs are his most numerous subjects. However, throughout his career beginning as early as 1954 in the small intimate picture of his grandmother's table, there has been evidence of his fascination with the still life. There is delicacy and miniaturization in the still lifes resulting in an uncommon refinement. That refined honed eye reveals visual sophistication despite his disarming manner and genuine belief that he "bumbles and stumbles around."

Long a close friend of Georgia O'Keeffe, in 1977 when he first saw her associate Juan Hamilton's abstract forms of clay or bronze closely associated with the shapes of Indian pots, he began photographing them. *Fragment X O*, 1983, the sparest and most open of all the series, he feels carries the purity of Brancusi's *Sleeping Muse*. When questioned how a single form is to be considered a still life arrangement, he answers that everything about it is arranged—light, the paper-covered table on which it rests, the natural plaster wall which serves as background, and the complex piece itself reminiscent of a

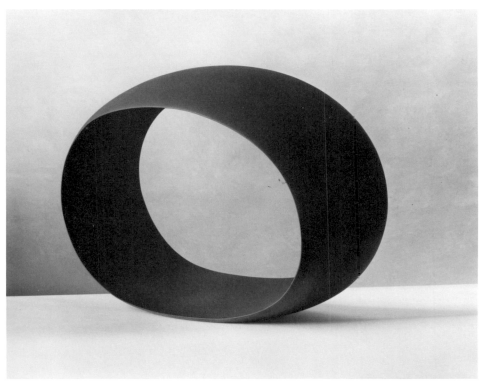

William Clift
*Portrait #6, Juan Hamilton
Sculpture, Fragment X O, 1983*

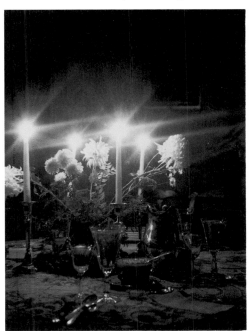

William Clift
Barbara's Table, Boston, 1956

mathematician's mobius band of many tones of black, as the interior and exterior of the bronze form are revealed at once. Above all, he stresses the importance of the picture's color, achieved through essential tonings. Hamilton entitled the piece *Fragment XO* to encompass both the circular and sharp angles of the configuration. It comes as a surprise to learn that this jewel-like form in the photograph is actually 2 1/2 ′ in height. For the photographer has compressed the scale into an intimately proportioned photograph of some 5 × 7 ″. The reduction of elements calls for the smaller than life-size format. Yet the complexity of the aforementioned parts provides the appropriate ambience for the elegant shape.

The same impulse which leads Clift to the compressed reduction in size, has led him to favor, in certain intimate, usually family-related subjects, the use of the Polaroid camera. To amateurs who blame their mediocre results with the SX70 on the lack of control it affords, Clift's success with the camera resulting in remarkably clear miniature photographs deserves close observation. It is this lack of control in its use which excites Clift. He loves the "spontaneous immediacy" of the Polaroid, even its inconsistent limited color spectrum which challenges him. He uses it, not to make notations as so many photographers and other artists do, but as the final product. He will suddenly go for the camera when something strikes his "heart and visual fancy."

By contrast with the open form of *Fragment X O, Portrait #2, Juan Hamilton Sculpture,* presents a fullness which only dense mass can accomplish. How satisfying is the variety of elements within this almost bare picture, the light-reflecting painted bronze "pot," smooth as satin, resting on a wooden table top, casting a softened grey shadow on the white plaster wall! That shadow which through toning takes on a brown hue to contrast with the nearly white light which plays upon it, is light reflected from a car window. Explaining the transient flickering pattern, Clift notes that light moves quickly, hence the term "still life" can be a misnomer. He emphasizes the importance of details which he considers highly significant, integral parts of the image—the two mere remnants of vigas, upper left and upper right. These elements hold the arrangement in a gentle enclosure and fix it in the delicately delineated corner. This scrupulously careful photographer, with all his artistry, claims not to look for meanings, only for "visual structure and emotional responses."

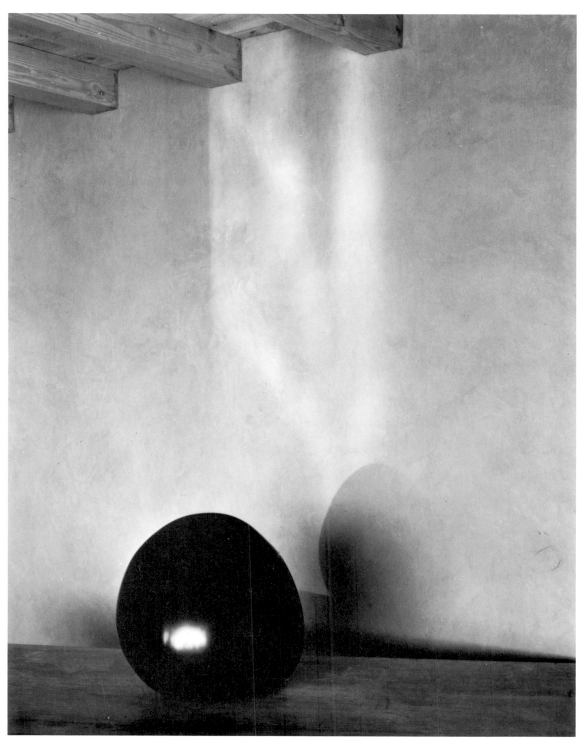

William Clift
Portrait #2, Juan Hamilton
Sculpture, 1981

Marie Cosindas

Color plates
on pages 55
and 56

To date, Tom Wolfe's essay, "Miss Aurora by Astral Projection" (*Marie Cosindas Color Photographs*, N.Y. Graphic Society, 1978), is according to the photographer, the most basic background concerning her work. In 1990 a new appraisal of thirty years of her important presence in photography will be written for a major exhibition. That she dedicated the 1978 book to Edwin H. Land is significant and immediately understandable to all familiar with her remarkable pioneer work in Polaroid color photographs. The originals have been seen only in her one-woman exhibitions since 1962, across the nation and in Europe. In group shows and in exhibitions where the photographs must be shipped, she doesn't exhibit the unique original Polaroids, but sends instead Type C or what is more preferable to her, the dye transfer prints made from them. For the originals she must have complete control in hanging and of the light level which she feels she cannot maintain from afar. She has found that the Polaroids, some twenty-five years old, which have been perfectly maintained, show no change. Some which have been exhibited do show certain color mutations.

It is somewhat ironic that this artist, who insists upon absolute control at every step of the process from composition to exposure to print, should have ever become involved with color film, which was all but impossible to control, or with the self-contained Polaroid process which admittedly removes the "making" of the photograph from the photographer's hand. Calling it "the darkroom in my hand," it allows her to modify the color in numerous exposures by working with varying exposure and development times. She has even been known to increase the temperature at which the print is developed by turning up the thermostat in her Boston studio.

At a retrospective at the Museum of Modern Art in 1966, the portraits and still lifes were taken with 4×5 Polacolor. She now works in 8×10 Polacolor-2, taken with a Calumet 8×10 view camera with a Polaroid back. She has said that the Polaroid medium was made for her and has been called its preeminent practitioner. She has been an experimental pioneer with Land's contribution to camera technology.

Although there is an intimation of time passed in certain of her still lifes, she has departed from the past styles she so admires in Dutch and Impressionist paintings. Her vibrant, deep colors are more integrated and harmonious, not separated into the individual brush strokes of a painting, and her very special perspectives

are those seen through a lens. These differences, however, didn't stop John Szarkowski, upon first seeing Cosindas' pictures, from saying, "I don't mean to sound blasphemous, but they look like paintings." Nor did his appraisal keep him from giving Cosindas her first major show and only the fourth to exhibit color work at the Museum of Modern Art in 1966.

The blanket and baby's breath we see in *Baby's Breath Bouquet, 1976,* are but two of certain objects she uses time and again in her still lifes, feeling they are like a "theme," a motif which runs through her work. The baby's breath, seen here in a three-foot bouquet, so large it was positioned on the floor, is at other times treated as a miniature arrangement. As we look closely at the brilliance of color relationships— here the punctuation of a red daisy picking up red patterns in the rug—we are reminded how perceptive her teacher, Ansel Adams, was in telling her early in her training, "You're shooting in black and white, but you're thinking in color." Perhaps more than the vivid pulsating color which gives a contemporary intensity to the picture is the revealing casualness of the composition which places it in a modernist idiom. Just as she opened the bouquet, as the removal of the paper package revealed the exciting textures and colors of the flowers, so she shot the arrangement, revealing that experienced excitement to the viewer. Like Samaras with whom she shares a Greek heritage, she crowds her pictures with decorative Byzantine patterns in crowded spaces. In *Baby's Breath Bouquet,* the space is so full

and the Baroque thrust toward the picture plane so strong that there is no border, no atmosphere surrounding the central composition. It is a thoroughly modernist concept.

On the other hand, the 1985 *William Powell Still Life,* at first glance carries an old-fashioned aura. It has the earmarks of a Vuillard interior—a portrait, a vase of flowers, period furniture. But look again. All has been heightened and intensified and brought out of the nineteenth century to the twentieth. That is no hand-painted portrait of the movie star, but a superb black and white photograph which serves as a foil, as does the subdued tonal background for the strong, vivid, gorgeous, yet natural colors of the cut roses, which still have the vitality to push upward and forward in the exquisitely controlled arrangement.

The better we know her work, the more we appreciate Tom Wolfe's title, referring to this photographer as goddess of the dawn carrying implications of a new beginning and of growth in light. He caught too the very special projection of her dynamic control of all aspects of creating a photograph.

Robert Cumming

Color plates on pages 56 and 57

Titles of several of Cumming's books reveal the range of subject matter we find in his photographs—*Picture Fictions, Interruptions in Landscape and Logic, Equilibrium and the Rotary Disc* and *Studio Still Lifes.* The works documented call upon his talents as a painter, printmaker, sculptor, and photographer in all of which roles he functions as an artist.

In an interview with James Alinder (Friends of Photography, *Untitled 18),* he was asked how the concepts for his unorthodox work developed and were realized. He explained that he's fascinated with "different phenomena and quirks in perception," that certain observations of unusual images from the real world, "perceptual glitches," are noted, sometimes sketched as "aides memoire," and later synthesized in his work. He readily admits to the inclusion of wit and irony, for the humor implies laughing at his own quirks. By the time we see these photographs, they have evolved from his sculptural constructions, his study of theatrical staging and lighting, model airplane building, architectural construction, and intense interest in movie stills, and an ongoing study of the physical forces of the universe. The ironic order he makes of this diversity is one we've never seen before; hence no single image explains itself. It is in the contemplation of numerous Cumming works that we begin to come to some understanding of his intentions. More of the puzzle is resolved when, as he often does, he displays the fabricated props or the sculptured forms he has made, together with the photograph on exhibit.

Before 1978 when he moved from California to Connecticut, he had used a Burke and James 8×10 view camera with a Schneider Symmar 300/500 convertible lens, which afforded him the resolved detail he so admired in Frederick Sommer's Arizona landscapes. He sought, even in conceptualist work not usually so concerned with detail, the enormous amount of information yielded by the view camera. Since his move back East "to find out who I am and where I come from," he has switched to the lighter, more easily maneuvered 4×5 format.

In a 1983 critique of Cumming's work, Charles Hagen (*Artforum,* Summer 1983), wrote that in all he does, this photographer recognizes "the relations between the mind and the world, between the abstract and the material, the ethereal and the mundane," and that his recognition of the relations between

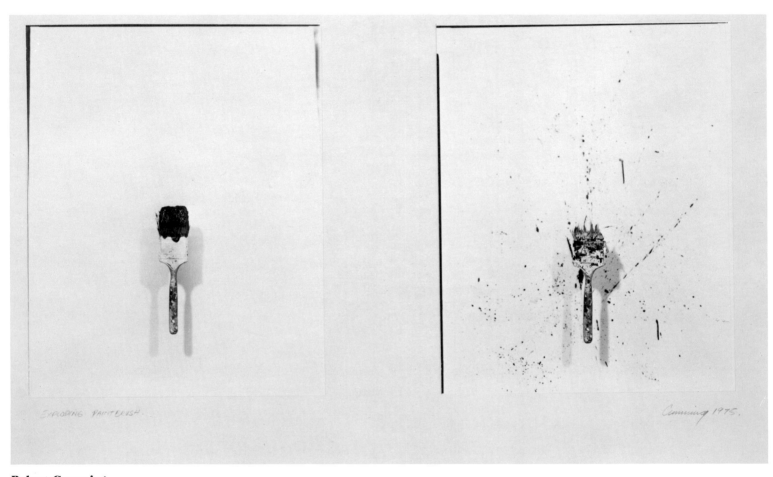

Robert Cumming
Exploding Paintbrush, 1975

signs and objects has been enhanced by mastery of the techniques needed to fabricate his objects.

The selected prints in this exhibition demonstrate a range of photographic techniques he favors in the works he identifies as still lifes. In an October 21, 1988 telephone conversation, he disclosed that *Exploding Paintbrush, 1975*, a diptych consisting of two 8×10 contact prints, was one of three or four in a series he did concerned with painting styles; this one being a kind of joke about abstract expressionism. *Plugs Dining at an Outlet*, a 20×24 Polaroid, would seem to be a spoof on the history of dining table still lifes. The table is set but with a thoroughly inedible feast. Here the fascination for the photographer represents a visual one in which all is out of sync. The outlets, expected to be on a wall, are not. The electric cords are straight rather than twined or twisted. The grill form of the table, fashioned by Cumming, is a kind of theme in many of his pieces, even sometimes having been scratched in a grid pattern into a negative. *Sex in the Seventies*, 1979, another 20×24 Polaroid, is to him a fresh way of seeing. The ale cans make

no reference to those by Jasper Johns as one might expect. But cut as they are, he finds their sharp edges antithetical to any concept of sex. Therefore, it's a humorous construction. The male and female figures are decoratively enframed within the work, a convention often used to enclose, especially in his charcoal drawings.

Since 1980, he has stopped making set up photographs, what he calls, "invented still lifes." Feeling that he had exhausted the genre and was ready for a change in his work, he has concentrated on the other forms of his creativity, on painting, sculpture, printmaking, and writing and is currently working on a novel.

According to Ned Rifkin, Curator of the Hirschhorn Museum and Sculpture Garden where his *Intuitive Inventions* were exhibited in 1988, his work "probes the relationship of truth to fiction in order to critique our technologically based society," in all forms. What it does which piques our interest, which puzzles us and wryly questions our preconceptions, is to heighten our perceptions of the world of visual things.

Jan Groover

This photographer, as is true of so many others in this exhibition, comes from a background in painting and drawing but found in photography she "didn't have to make things up, everything was already there." Edward Weston expressed a similar notion when he pondered why anyone had to create sculpture, since the forms already exist and need only to be discovered. We know it's not quite that simple in either case. But the idea of discovery of ordinary objects, seen in extraordinary ways, is what engages the still life photographer.

Groover's first photographs would seem to be the antithesis of her more recent still lifes. In the 1970s she concentrated on multiple serial Type C color diptychs and triptychs of urban and highway scenes in a single frame. Holding a still camera, she sought the action which passed before the lens in shifting perspectives, believing as she told Lee Witkin, that in photography, although you are "stuck with the real world," you are really stuck with "whatever your mind makes of things." The patterns of moving, sometimes blurred images, have given way since 1978 to variations of close-up patterns we find in the larger than life still lifes, in color, and black and white silver or platinum-palladium prints. Susan Kismaric has related Groover's use of the hand-applied platinum-palladium process to the working methods of a painter and to the painter's appreciation of the beauties of these rich metals.

The dramatic framing of the urban landscapes continues in the still lifes to bring those images of the 1970s up close to the picture plane to become a heightened reality of familiar kitchen utensils, out of

scale and therefore in contrast to the quiet domesticity of Chardin's pictures of similar subjects. Her work of the 1980s is in smaller scale and more modulated tones, with space between objects. This tends to isolate them and to create a world reduced in size but more open spatially. Strange intrusions by live cats, clay and plastic toy animals, and workshop tools inhabit the household worlds of bottles, vases, funnels, pitchers, oil cans, knives, peppers, onions, fruits, vegetables, and flowers. No strong central composition holds these objects together. The choice of placement is arbitrary and intuitively felt by the photographer. Such eccentric choices affirm Schapiro's emphasis on the complete freedom asserted by the artist who creates still lifes when he writes, "The still life on the table is an objective example of the formed but constantly rearranged, the freely disposable in reality and therefore connate with an idea of artistic liberty."

These are not "nourittures," arrangements of food which nurture, nor objects lovingly cared for in the home. They remain props of an artist's studio, an artist who presupposes our knowledge of the past from which they have departed.

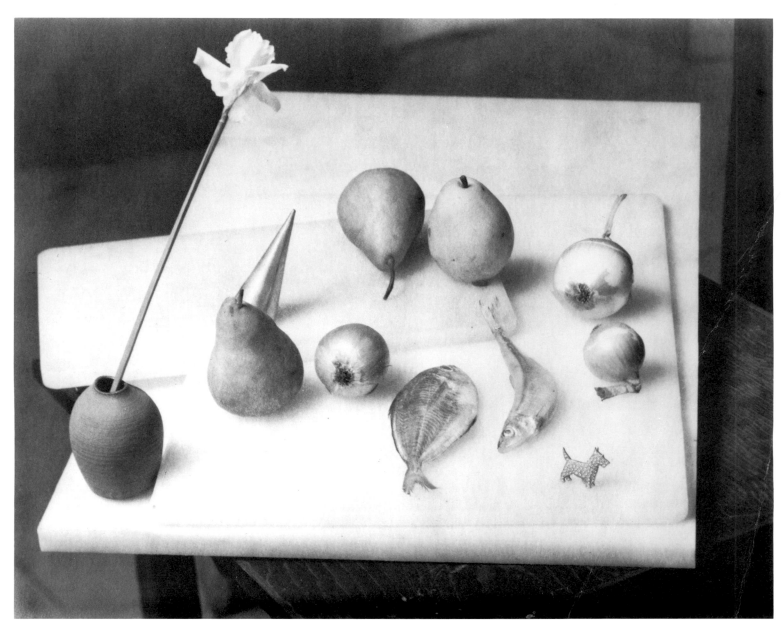

Jan Groover
Untitled, 1982

Betty Hahn

Color plates on pages 59 and 60

More than a decade ago, Betty Hahn's work in non-traditional processes was exhibited in Gallery 210 at the University of Missouri-St. Louis, in *Aspects of American Photography, 1976*. Even earlier she began a career of experimentation which she has pursued during all her professional life. She is one whose training in painting, graphic design, and photography has equipped her with knowledge of the breadth of artistic materials, and whose own wit and imagination has creatively directed her use of them. What she exhibited in the 1976 show, utilizing the sensual appeal of silk, satin, velvet, or muslim combined with a photographic image, was a three-dimensional soft daguerreotype. A xerox print on plastic-coated, silvered fabric, framed in gold metallic cloth and tinselled braid, and backed in black velvet, took the form of a $9\frac{1}{2} \times 11\frac{1}{2} \times 3''$ daguerreotype. It is a unique piece and a clever witticism about the beauty and uniqueness of the first photographic process.

Hahn's work in the early gum-bichromate process in prints on fabric embellished with hand stitchery, with color prints made with the cheap plastic Nick-a-Matic camera, cyanotypes with Flair pen additions, hand-colored silver prints and straight silver gelatin photographs, all preceded the work in still another photographic process, the Polaroid, which we see in this exhibition. She was one of the first group of photographers, including Cumming, Groover, Parker, Cosindas, and Samaras seen here, invited by the Polaroid Corporation to use its $20 \times 24''$ 1976 Land system in the Ames Street, Cambridge, studio. She attributes the flowering of photographic still lifes in the last decade to Polaroid's influence on the photographers who were intrigued by the large format camera. Weighing 200 pounds, with a $60''$ bellows, the camera is not transportable, but must be used on the premises. Hence, the photographer must bring his or her own subjects and arrange them in situ. Hahn says the camera is built like a big doghouse with a door on the back. It is on rollers with the developer gravity fed. The developer pod is $20''$ and the length of the film and paper is $24''$, which explains why these pictures are vertical.

What we note with such pleasure in the quality of Hahn's botanical layouts is a sharp grainless clarity, brilliant saturated colors, and extraordinary detail afforded by the Polaroid $20 \times 24''$ system using Polacolor film with an ASA of 80. Because the finished instant color print takes only 75 seconds to develop, the photographer sees the finished print at once and can makes changes in lighting and composition of the work in progress.

Turning these attributes to her own ends, Hahn has conceived of modernizing traditional botanical prints. Even the titles, such as "Plate 79" or "Tab 11" resemble those in eighteenth- and nineteenth-century botanicals. But these are not scientific illustrations, rather they are artful still lifes of fresh flowers, gracefully placed on sheets of drawings made by Hahn with a magic marker on charcoal paper to simulate the look of the hand-colored lithographs, the medium of early botanical prints which she collects and admires. These works reveal the most detail of any of her photographs, delineating parts of plant systems, roots, leaves, stems, and flowers.

Yin and Yang, a three-panel piece, fits in her series of mystery still lifes in which she puts together objects in her studio to stand for clues to the particular concept she is developing. To Hahn, this work expresses photographically the Taoist idea of the harmony of opposites with the female represented in the dark, soft, silky purse, and the male in the white, hard marble and the gun. The Occidental is implied in the violence inherent in the gun and the Oriental in the Chinese newspaper and decorative beauty of the purse.

The pieces in this exhibit reveal but a portion of artful techniques, by hand and by machine, which occupy Hahn's considerations of the latent possibilities of the medium. Judging by her past record of creativity, it is to be expected that she will continue to seek still others and find expression in photography for them.

Barbara Kasten

"Through the looking glass" is a phrase not reserved for Lewis Carroll's Alice alone, but has been used in writing of the wonderland worlds of lights, colors, and mirrors created by Barbara Kasten. In the 1985 Capp Street Project, "Exact Seeing," the viewer was also the participant who could literally walk through the magical space of that life-size installation. She has erected her structures to be photographed at the Whitney Museum, in the World Financial Center, and at the Equitable Building in New York. The photographs shown here have given new meaning to "Mirror Image," the term applied to Daguerre's precise pictures on mirrored reflecting surfaces 150 years ago. Kasten's shaped mylar mirrors are elements within the pictures, placed to reflect what is within and outside the compositions, to expand interior spaces, and to become color forms when covered with stretched cloth.

She has given added meaning to the concept of the straight photograph, taking her inspiration, not from an *f.64* inheritance, but from Moholy Nagy who defined photographic vision as "exact seeing by means of direct records of forms produced by light." All the manipulation is done before the picture is taken, not in the darkroom. Using as forms industrial detritus such as styrofoam pieces, glass bricks, copper tubing, and, lately, Classical references in Corinthian columns, all generally white or gray or colorless objects, she "paints" with colored gels to create brand new colors.

Her way of producing the on-location, complex, not-so-still still lifes is as original as what she has chosen to photograph. She would seem to work contra to the capability of the camera, in that the speed possible for the act is slowed by the preliminary process in preparing what is to be photographed. Using a crew of eight, six to handle the lights, one camera assistant and a gofer plus Tom Feldman as head of her crew, it took six hours to accomplish the picture done at the Whitney Museum. She proceeds by making preliminary sketches, hand-colored to determine which gels will be used over the lights. She sets the 4×5 or 8×10 view camera and then makes Polaroid tests, shooting sheets of Polaroid Professional Chrome transparency film. A custom printer,

Michael Wilder, makes Cibachrome prints up to $30 \times 40''$ from the transparencies in editions of nine. Cibachrome is favored because of its properties of glossy surface and high color saturation. Her work at a single location, lasting several hours, can cost $10,000 which she funds through grants and with her own money.

Her talents were early recognized in awards of a Fulbright Hays Fellowship, one from the NEA, Polaroid Collection, and a Guggenheim Fellowship. Her work has been included in individual and group shows across the country and in Japan since 1979, exhibitions organized around themes which categorize the complexity of her work—on space, light, color, constructions, and still life. Her photographs are included in the country's major museums' photographic collections, including those of the Museum of Modern Art, the Art Institute of Chicago, the Center for Creative Photography, the Metropolitan Museum, and the International Museum of Photography at George Eastman House.

Frank Majore

Color plates
on pages 62
and 63

This photographer has turned to America's commitment to big business and consumerism, as identified by Susan Sontag, and made that world of glitz and kitsch and advertising into a new kind of still life. Nothing is being advertised here, but the grammar of expensive ads has been used—spot lighting, high intense carnival colors, and dramatic presentation. But by juxtaposing differing objects, he redirects the images from sales promotion to imagination. If Metzner utilizes a style evolved from her private and commercial work so that both are equally important, Majore has lifted from the sensuosity of a heightened commercialism, a stylization without a product for sale. In a 1985 interview he said, "I eliminate the products and push backgrounds forward. I'm asking, how does advertising stir up desire?" His roots lie not in the seventeenth-century still life reflecting the good comfortable bourgeoisie table of plenty, but in the video screen and slick magazine pages. As his objects are not being offered for sale, neither do they stand for the symbols traditionally associated with them. A pearl is not the pearl of salvation, nor is a rose either a Roman symbol of victory or the flower of Venus. Neither does his crystal glass with olives at its base connote a symbol of purity, nor are we misled into believing any relation to traditions of the past are implied. Yet these Cibachromes foist their with-it, modern artifice upon us. Their dissonant jazzy overtness is their strength. His modern idiom is achieved with orchestrated contemporary technology by the addition of slide projection and multiple exposures.

Art about art is an old and respected tradition in art history. From Marcantonio Raimondi's *Judgment of Paris* after Raphael, to Manet's *Dejeuner Sur L'Herbe* after Giorgione's *Fête Champêtre* to Picasso's own borrowings from Velasquez, the history of art is rich with quotations. The modernist or post-modernist, however, does not exclude all but high art. Rather he takes as freely from commercial imagery as he pleases with Lichtenstein audaciously redoing the comic strip, Warhol silkscreening and painting from previously published halftones. Here Majore extracts the format and subverts the intent of the ad world to produce blatantly gorgeous photographs which rely for their success in the last analysis, on the photographic beauty of light and color on absorbing and reflective surfaces of familiar objects—the banality of which has been transcended by the camera.

Robert Mapplethorpe

High drama created by brilliant light, spare composition, and play of shadow forms have marked Mapplethorpe's still lifes since they were first publicly exhibited and enthusiastically received in 1976. The lushness we associate with flower pictures has been replaced by intensity, a certain coldness, sometimes overt aggression and assertive sensuosity, to connote strength and intense beauty in a new perspective in flower pieces. The negative space in clear cold light in Mapplethorpe's still lifes gives them a pristine quality, removed from the overripe decay found in many earlier painted versions. No bees pollinate these flowers; no butterflies alight upon them. In his black and white works, Mapplethorpe defies Friedlander's premise on still life, made in 1963, that a flower means little without color, "without its material idiosyncracy." The black and whiteness of these pictures dramatizes the zones of black and white photography to a heightened degree and thrusts flower imagery upon us assertively.

It is not the ripeness of Fenton's *Ivory Cup and Fruit,* c. 1860; rather it is the artifice of the painted flower on a tabletop *Chez Mondrian,* caught by Kertesz, which comes to mind as we contemplate Mapplethorpe's reshaping of the idea of flowers as subjects. Meyer Schapiro has concluded that the flowers in still lifes, since they are no longer presented in their natural environment, might be replaced by artificial plants. Mapplethorpe's flowers are not artificial in the sense that they are imitations of those found in nature, but we do feel they have been seen by an artificer, one who has devised through his camera a new persona for

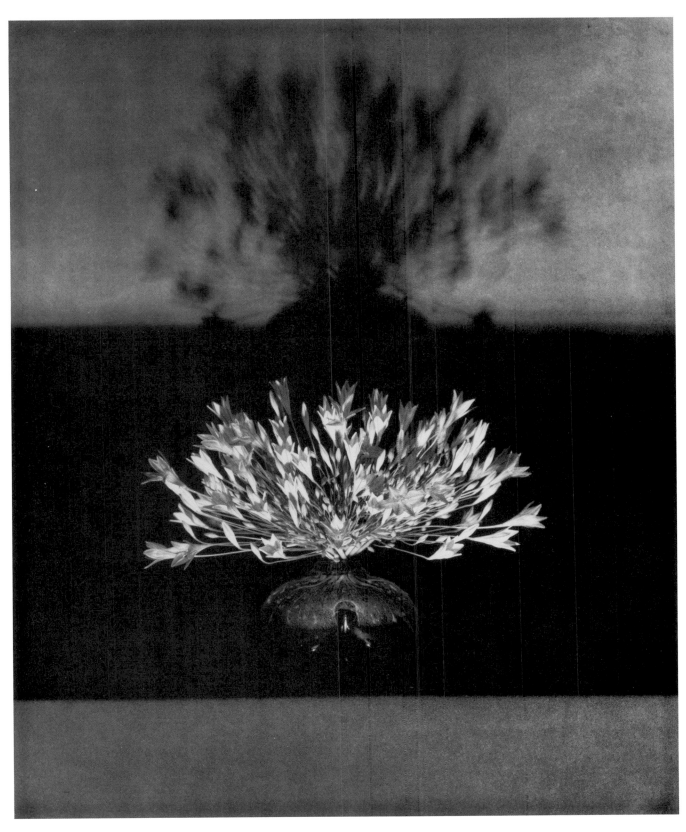

Robert Mapplethorpe
Untitled, c. 1982

the botanical specimen.

Somewhat more muted works in this photographer's "oeuvre" have been made so because of the particular photographic media used. In this exhibition the gravure still life, presenting the bowl of flowers and its complete darkened shadow, recall the positive-negative images of Talbot's calotypes made with paper negatives. The photogravure, an ink, not a silver, process, affords a softening of edges and tonalities seen in the bands of light of which the picture is composed. In *Irises,* 1986, a silver print, feathered edges of an implied off-camera Venetian blind and those highlighting the bowl which holds the bouquet, further enhance delicate light patterns. Whereas the elements of traditional still lifes are richly varied, those seen here are singular. A single flower may be the subject, but the shadow forms and light patterns or areas of color as in *Orchid,* 1986, provide those divisions of space and zones of activity previously supplied by more numerous objects.

Perhaps it is with the *Calla Lily,* 1986, that we are most closely reminded of the feelings elicited by the photographer's more sensational studies of male nudes. He himself has recalled that the powerful feeling he had upon his first encounter with pornographic male magazines, was the feeling he sought in a piece of art. Here the calla lily, poised over its own shadow, evokes the powerful responses he seeks.

In 1988 this artist's particular accomplishments were acclaimed and recognized by the Stedelijk Museum in Amsterdam, the National Portrait Gallery in London, New York's Whitney Museum, and the Institute of Contemporary Art in Philadelphia, by major retrospectives. No small achievement for one whose career to date spans less than two decades.

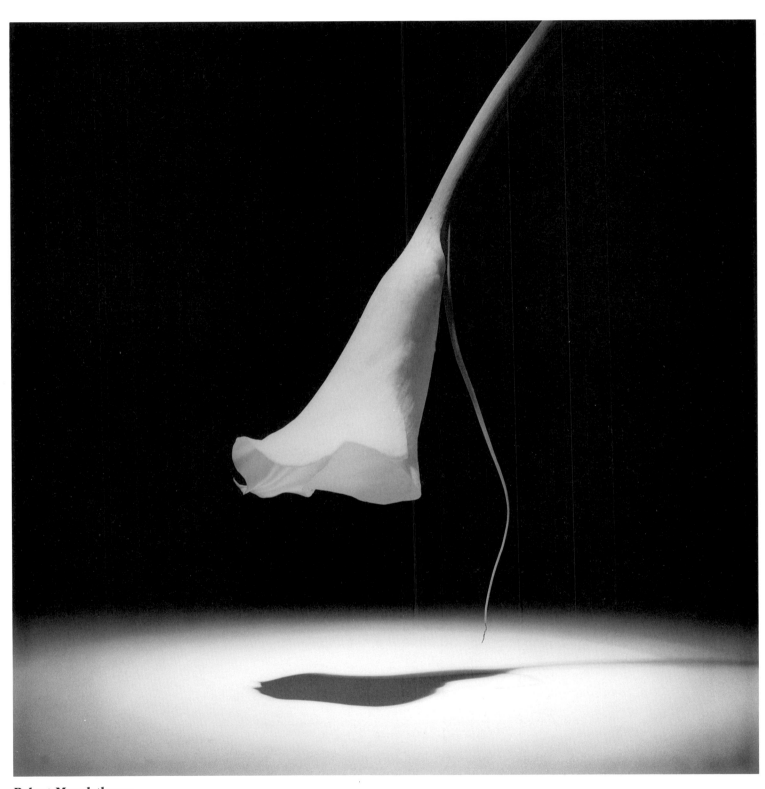

Robert Mapplethorpe
Calla Lily, 1986

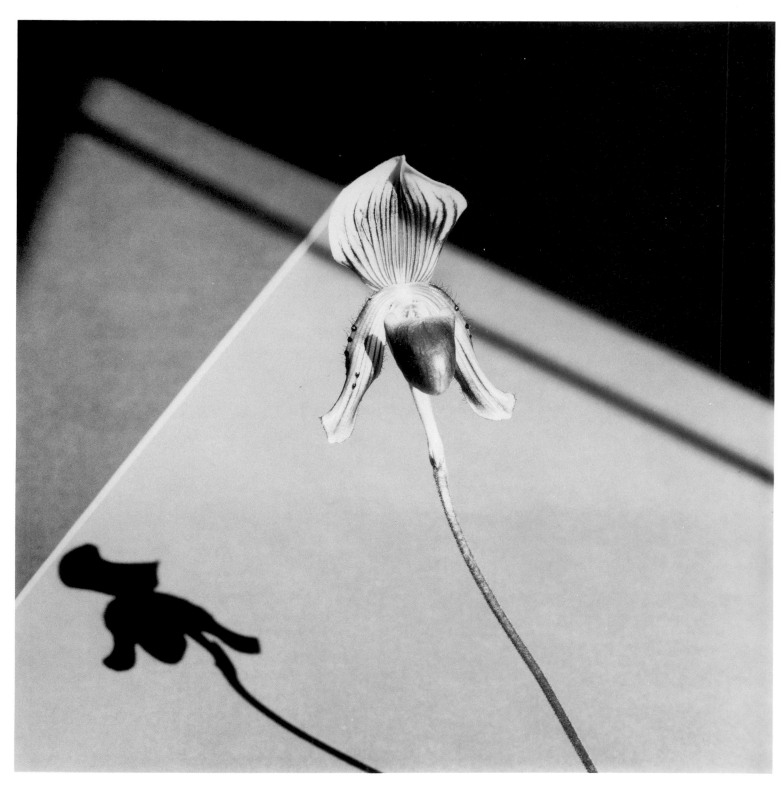

Robert Mapplethorpe
Orchid, 1986

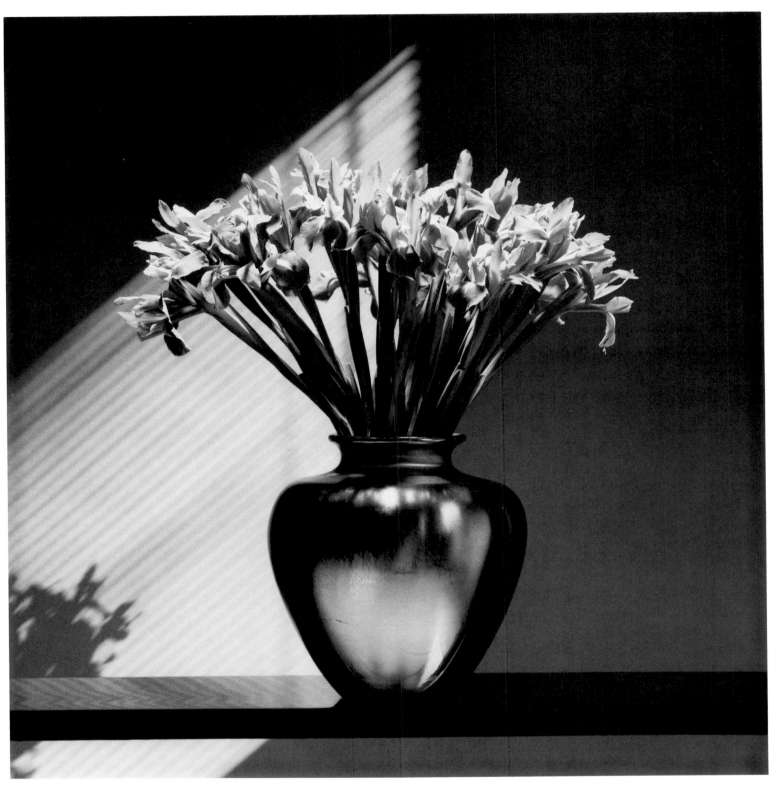

Robert Mapplethorpe
Irises, 1986

Sheila Metzner

Color plates on pages 64 and 65

To become involved with Sheila Metzner's photographs is to enter a world of beautiful forms and colors, of Serge Mouille lighting prototypes, of Dunand vases, of Fiestaware, Art Deco, and exotic flowers. In a lecture at the Museum of Modern Art, April 23, 1988, she spoke of her work as a collaboration, of family, assistants and housekeepers, and the daily hard work which "lifts the spirit." She noted that her images are a direct correspondence with life. Continuing, she communicated her own response to the camera, saying that she speaks freely through it and that she looks into the room of the camera and sees what inhabits that room. What inhabits the room in these still lifes is what she has artfully chosen and placed there. She feels humbled by the moment when a photograph comes together when it all opens up, and she sees it in the camera. Her audience laughed when she excitedly stated that at that moment, "You're just lucky to be there in front of it and just lucky enough to push the button."

Like many others in this exhibition, she was first a painter before becoming a photographer. She did not make color prints until about 1977 when she discovered the Fresson Process, invented by Theodore Fresson in the early part of the twentieth century and passed down from one generation to the next in absolute secrecy. In 1950, Pierre Fresson, Theodore's son, adapted the original Fresson process to color, calling it Quadrichromie (four-color separations). Today Theodore's grandson Michel runs the Atelier Fresson in a village outside Paris and carefully selects the few photographers for whom he will print. The process is believed to be the most permanent color process available today expected to last 100 years under reasonable light conditions before any change can be detected. Metzner chooses it because of its stability and because it uses not just four colors but seven or eight, is a pigment process and has black tonalities. She wants her prints to "last longer than I do."

Owen Edwards has noted that, like post-modern architects, she reacts to the straightness and purity of the modern aesthetic. The Fresson process has produced the effects she seeks in her pictures, the softness and texture of gum bichromate prints and the muting of color and light reflections, resulting in pictures reminiscent of 1907 Lumiere color work. These exquisite still lifes have been likened to Seurat in textural pointillism and to Balthus in the enlarged shapes, pastel colorations, and often surreal formal arrangements. Working with a 35mm camera and old lenses, her photographs are enlarged by Fresson to create works which are new and of her time, especially in their shallow spatiality, while they carry intimations of an earlier era and sensibility.

Metzner does not distinguish between her personal work which we see in this exhibition and her commercial work; it is all "of a piece." This attitude is shared with Irving Penn, both of whom have long been amicably associated with Condé Nast publications, and both of whom have produced commercial work of the highest artistry. Until her work for Kohler, published in *HG, House & Garden,* October 1988, her pictures were published directly from the chrome, not the print. In the Kohler advertisement, the original print was used. It may be the first time that a commercial advertisement carried so full an identification: As I See It #1 in a series, Sheila Metzner, "The Arrangement", Photography/Fresson Print. In it she has made a full still life, incorporating plumbing fixtures, two Dunand vases, a perfume bottle, and a flower.

A significant colorist, Metzner also obviously seeks metallic surfaces which reflect the gentle quality of light we find in her photographs. These have been found in unusual decorative art objects. Jean Dunand made the hand hammered metal vases we see in two of the exhibited prints. To the metal, the artist applied Japanese lacquer to each vase, each of which is unique. Made in the 1920s, these Art Deco pieces all are numbered and signed. Metzner's keen eye has responded to these unusual forms. She began collecting them long before they became the fashionable collectors' items they are today, sometimes bringing more than $100,000 each. The same hand-crafted beautifully designed metal forms are seen in Serge Mouille's light shades, another unusual form identified by Metzner as appropriate vehicles to transmit the particular low level light she desires. As her surfaces have a matte finish, which she describes as "like a glaze on fine porcelain," so the silver subjects are not brilliantly metallic, but rather have a burnished patina. Serge Mouille's 1950s aluminum lighting reflectors reveal the fine craftsmanship of the Dunand vases. Although they are repoussé forms produced by cutting, turning, and manually shaping, they are industrial products for clients who were architects, designers, and decorators. The Kohler plumbing fixtures, the Dunand vases, and the Mouille reflectors have all been treated and positioned within the various compositions by this artist with the same meticulous care, so that we better understand the oneness of all she does as a consummate photographer. Seeing the world as arranged, perceiving no difference between still life and "everything else," she has contributed new dimensions to the modernist concept of what the still life can be.

Olivia Parker

The introduction to Olivia Parker's most recent book, *Weighing the Planets,* 1987, is entitled "Anima Motrix" which stands for the moving spirit in the unknown. Her essay, like her refined images, speaks of the unknown mysteries of the world of memories, associations, time, and knowledge. Asserting that her process is visual and that meanings cannot be found in verbal terms, she has produced a body of work which piques our thoughts, implies connectives, and gives pleasure in sheer photographic beauty achieved through her mastery of the medium and consummate taste in bringing disparate objects together. The objects, she feels, become a language for her, and indeed they do for all who concentrate upon them. The sense of time past which the constructions connote, and the very fact that they are contained objects, often within a visible box frame, cannot help but remind us of precious daguerreotypes, completely protected and enclosed within their cases. But Parker is quick to state that although the velvet-lined case is a thing of the past, the photograph retains its power to call attention to what is within its edges. Here again, is yet another explicit example of the photograph as an object itself. In defining her own work, the photographer defines the modern photographic still life. Since she concedes her inability to explain each picture, she invites us to participate as we will.

Although there would seem to be no similarity whatsoever between Parker's work and that of Lucas Samaras, it is interesting that both of them speak of transformations in what they do. In the last analysis, all art works are transformations. While Samaras transforms himself in Polaroid self-portraits which are manipulated while the emulsion is still malleable, and transforms the still life by cutting and reassembling other Polaroids, Parker uses the term to refer to those changes which occur between what she sees and what happens in a silver print. Further transformations occur as she juxtaposes distinctly different objects, giving them fresh associations.

One might expect to gain insight into her method of working by accompanying her on visits to antique shops. There she examines everything, but purchases little, not actually seeking anything in particular but responding intuitively to those varied things which are, as she says, "rich in human implications." A seashore or a well-trafficked city street might provide as much material for her still lifes as the finest shop. What has found its way into

Olivia Parker
Carrousel, 1982

her "collections" may be seen in the photographs, as though they were made to order for her purposes, so right are their associative qualities, light-absorbing capabilities, formal characteristics, and metaphoric suggestions. Her objects, according to Gyogy Kepes are "at the edge of change, pregnant with possibilities." Kepes likens them to still lifes by Chardin and Morandi; she acknowledges as well Cotan's paintings and the boxes of Cornell and Boghosian as inspirations for her work.

The titles of Parker's books express the same sensitive vision and carry the same poetic connotations as her photographs—*Signs of Life* (Godine, 1978), *Under the Looking Glass* (New York Graphic Society, 1983) and *Weighing the Planets* (New York Graphic Society, 1987). In all, the device of leaving visible the dark border made by the plate holder serves to separate and yet enclose each composition. In addition, this notion is further enhanced by the use of a shallow open box which contains the objects in certain pictures, such as *Site II, Deer,* as seen from above. These enframements may be likened to Roman wall paintings of objects and fruit in trompe l'oeil cupboards and

niches, to Charles Bird King's *Poor Artist's Cupboard,* 1812, or to Picasso's *Still Life with Chair Caning,* 1911-12, with the picture as a tray with a rope border. It is interesting to note that her more recent still lifes are not tabletop arrangements; rather the artist has eliminated signs of that kind of placement, affording her opportunity to provide various tonal and textural backgrounds for her collage-like compositions, all bathed in softened zones of light. Old manuscripts or music scores or encyclopedia pages, often on deckle-edged papers and stained by time, upon which her bits and pieces of memories, mysteries, shadows, flowers, shells, crystals, and a myriad of other forms are placed, receive a delicate light and provide the area on which her diverse subjects are brought together. The mysterious page from some antique astrological text forms the central image of the photograph "Weighing the Planets." It is but one collaged element in the picture which is superimposed by shadows of a human presence. In the beautiful rich patina which selenium toning gives to a photograph, she has expressed what she seeks in her work, an expression of "Anima Motrix."

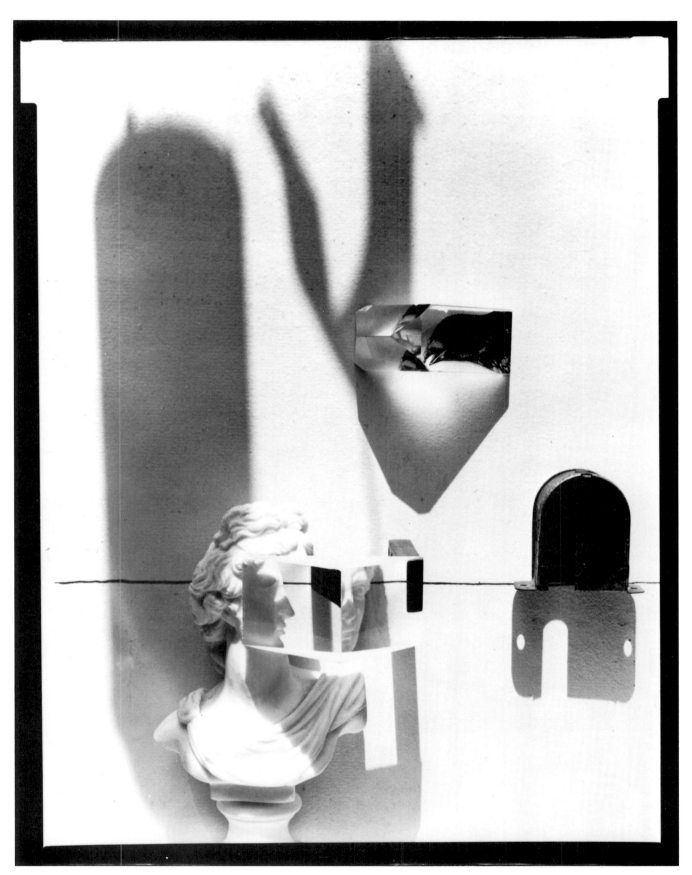

Olivia Parker
Statue Seen by Man and
Observed by a Pigeon, 1984

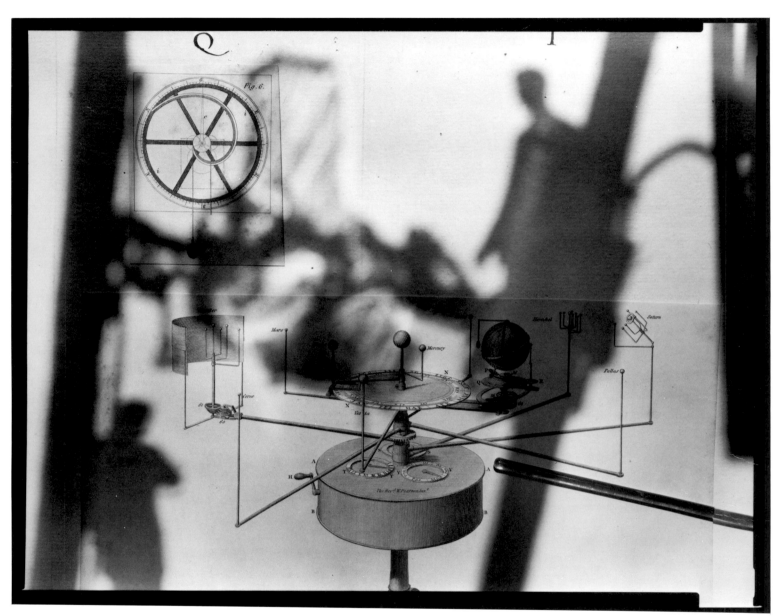

Olivia Parker
Weighing the Planets, 1984

Olivia Parker
Site II, Deer, 1981

Irving Penn

Trained at the Philadelphia Museum School of Industrial Arts, Irving Penn was tutored and encouraged there by Alexey Brodovitch, art director of *Harper's Bazaar,* who employed him after graduation in 1938 as a commercial artist. A year of photographing and painting in Mexico followed. Then he returned to New York to work for the second strong mentor of his career, Alexander Liberman at *Vogue Magazine,* where his first still life color photograph became the October 1, 1943, cover picture. The importance of these two men in his career deserves mention as we closely examine what John Szarkowski (*Irving Penn,* Museum of Modern Art, 1984) has called the "signature" of Penn. Make no mistake, there is a strong signature, or what to Katherine Anne Porter was the artist's "thumbprint," which distinguishes Irving Penn's prodigious body of work. This is evident in fashion photography, portraiture, nudes or still life, whether we refer to the commercial assignments, or to his own work. It is the Penn-ness of Penn to which we respond, the disarming simplicity, strength of composition, perfection of light quality, originality of conception, and power of presentation consistently in every photograph. Like Metzner, he doesn't distinguish in importance between the commercial and non-commercial work. Both nourish him; each affords the necessary foil against the characteristics of the other.

In a March 17, 1988, interview he spoke openly of the "balanced diet" both provide saying that each feeds the other. He went on to explain that at *Vogue* he deals in perfectionism which forces him to other things.

How deftly he handles the clinical purity of Clinique cosmetics on the one hand, and the detritus found in the gutter—old kleenex, cigarette butts and empty packages, paper cups and flattened deli cartons, on the other. Stylistically, similarities are to be found in the seamless-paper backgrounds of the elegant isolated fashion models and the bare simplified portraits of equally elegant natives seen in *Worlds in a Small Room* (Viking Press, 1974) from Nepal, New Guinea, Morocco, Cuzco, Crete, Spain, and Dahomey. To such exotic places he carries a specially designed portable studio consisting of a system of aluminum pipes and a tent. The assembly of such an unusual workplace is rehearsed in his New York studio to operate smoothly wherever he is. The ambience such a setting creates is as timeless, uncluttered, and non- specific as that of the fashion photograph. The natives, isolated from their natural environments, can be seen with intensity.

Absence of setting defines the still lifes too. They also are seen, in platinum, palladium, and silver, against the whiteness of the paper in the cigarette and kleenex pictures and in neutral environments in such tabletop

Irving Penn
The Spilled Cream, New York,
1980

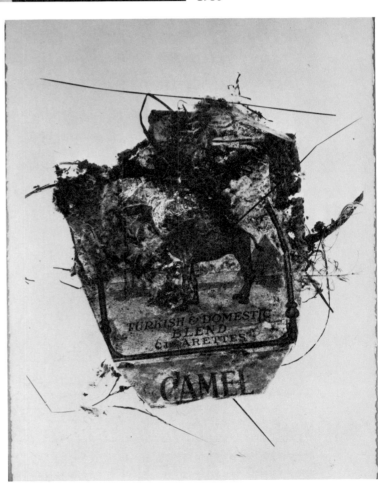

Irving Penn
Camel Pack, New York, 1975

arrangements as *Blast, New York,* 1980. These forms, steel blocks collected by his son, transcend their own materialism to become, to the extent a photograph of something seen can become, almost the pure abstractions Cezanne referred to in his statement about cubes, cones, and spheres. The thirteen forms, variously placed to reflect and deflect light, precariously balanced in a completely original composition, reveal density, compactness, and weightiness in a scale of tonalities possible only in a photographic print. All the forms and the surface on which they are placed have special textures which result in a complex richness not expected with such economy of means.

The weighty darkness of *Blast, New York,* 1980 is in contrast to the brilliant whiteness, no less weighty, in *The Spilled Cream* of the same year. The broken saucer within the composition seems a quotation of the portion of the *Broken Pitcher,* published in a project for *Vogue* in 1947. The satisfying rich scale of *The Spilled Cream* heightens the drama of the earlier work in which the shattered form is but a detail in an implied narrative work.

Surely with this photographer, the original term for the still life as a "nature morte" is a misnomer. No matter what he uses to build the still life; no matter how dead, as with the lion skulls found in a Prague museum; or desiccated, as with the cigarette stubs, crumpled discolored street refuse; what has obsessed him, to use his own word about such materials, is the dust, the coating of time they carry. When Cennino

Cennini instructs the Renaissance artist to crush and examine a piece of cloth to find in its folds a mountain range, so Penn holds in a lens focused on the channels of a soft tissue, a complete scale of greyed tonalities and evidence, as that given by ancient coins, of human use.

Using platinum and palladium metals, he produces a rich tonal scale on prepared hand-coated papers which come to him affixed to aluminum supports. The paper is taut and sensitized to receive the process. He may use four negatives of varied exposures which he prints in perfect register, achieving such depth and beauty that one is perplexed about how it has been attained.

This is an artist who has no trappings, who admittedly does not feed on photography, but on painting, on Leger, Matisse, Picasso, Morandi, Giotto, Ucello, and De Chirico. This is a man whose body of work springs from a remarkable sensitivity, modesty and perceptive intelligence, and who is obsessed by all that shows evidence of life.

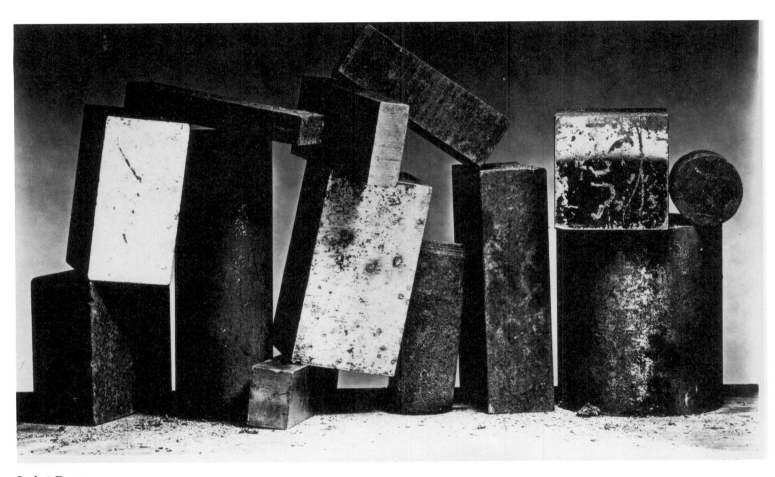

Irving Penn
Blast, New York, 1980

Lucas Samaras

Color plates on pages 66 and 67

What kind of artist is Lucas Samaras? He is a sculptor who creates chairs one can't sit upon, books that can't be read, boxes so full of pins or knives they can't be used, and still lifes that won't hold still. The variety and quantity of his artistic production is astounding as is the dynamic energy of his styles.

Mondrian is credited with stating that all artists have roots, but that they just shouldn't show too much. We certainly can't accuse this one of being derivative. The fragmented planes of Cubism, the Surrealism of Man Ray, the Dada of Dali, the neon colors of the theatre and ad worlds, and the disjointed introspection of a post-Freudian period all form part of the mix. Samaras' work does not fit easily in any named contemporary movement. He belongs to no school of art. Only when we look to the increasing number of artists who appropriate photography, who use it as one medium in the production of art, who have blurred the boundaries between painting and photography, and whose dealers are generally not those who exclusively represent photographers, do we find a niche for Samaras. The subject of the two camps was discussed last year in an aptly entitled study, "It's Art, But Is It Photography?" (Richard B. Woodward, *New York Times Magazine*, Oct. 9, 1988).

Within his own oeuvre, Samaras' Polacolor assemblage panoramas, as these still lifes are identified, would seem to evolve from the same kaleidoscopic, endlessly broken imagery, that spatial ambiguity, afforded by the mirror-lined "Room 2", 1966. Every figure reflected in that environment is segmented and seen from all angles, an activity simulated in the slashed strips of the panorama still lifes. Ideationally, these intensely personal domestic constructions reveal extensions of his personality. It is the same self-search of the photographer launched in the manipulated emulsions of the Polaroid Photo-Transformations and numerous partial and full nude studies of his body in acid Polacolor upon dazzling patterns which he calls Autopolaroids.

Born in Macedonia, Greece, Samaras wrote in 1968, "Greece is my prehistory, my preliterate past, my unconsciousness, my fantasy. America is my history, my consciousness, my adult life, my reality."

The consanguinity between past and present in his life and work weaves throughout these still lifes. If evidence of his native Greece is not obvious, except in what he calls a Byzantine quality, a certain gorgeousness, certainly the modernism of the urban American experience, is. In his "Conversation with a Work of Art," in which Peter Plagens (*Aperture*, Ninety-Six, Fall, 1984) simulates a discussion between Samaras and his work, we gain some insight into his methods and intentions. He considers the piece not a photograph, but a work of art, primarily because it isn't a single image printed from a negative. It is more a collage or assemblage of sliced, slashed horizontal strips. He uses the striation device to counteract the concept of a staged still life and to emphasize "the uncertainty of perception." He asserts that he has once and for all answered the first Eastman Kodak ad, "You push the button, we'll do the rest." Finally, the photographic work of art demonstrates that what was seen in the lens is not what's important. Samaras' imagination, which stood behind it, is.

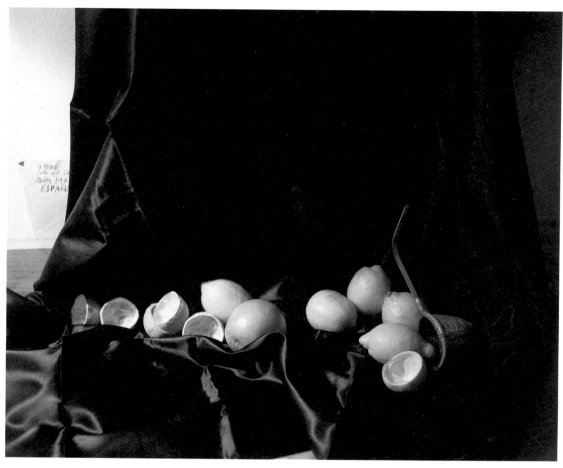

Clegg and Guttmann
*Sunkist Lemons
(with a Tea Strainer),* 1987

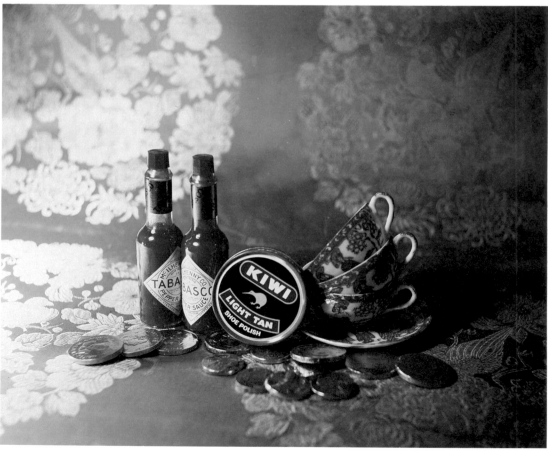

Clegg and Guttmann
TABA-BASCO, 1985

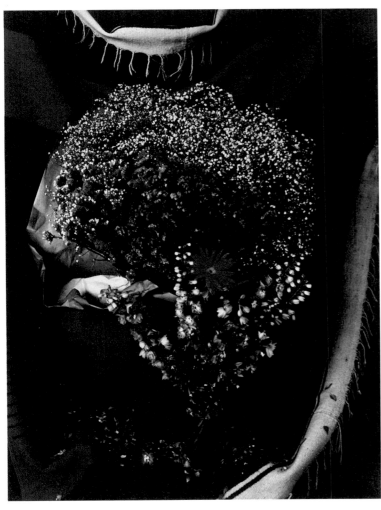

Marie Cosindas
Baby's Breath Bouquet, 1976

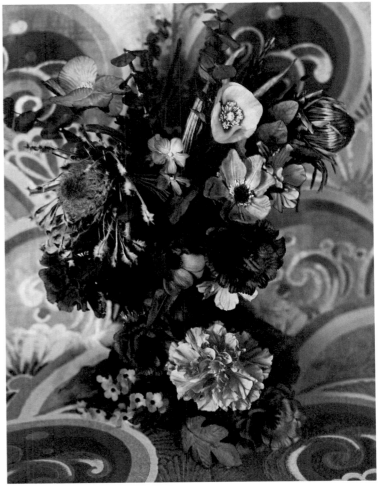

Marie Cosindas
Japanese Floral, 1982

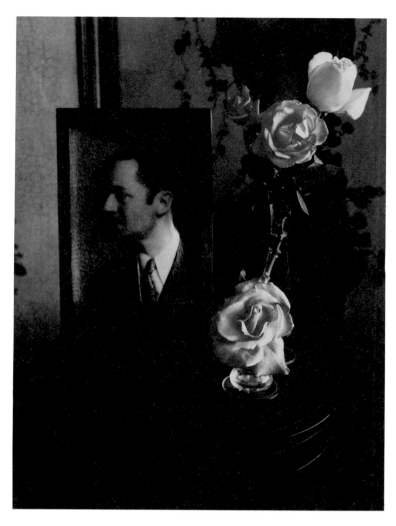

Marie Cosindas
William Powell Still Life, 1985

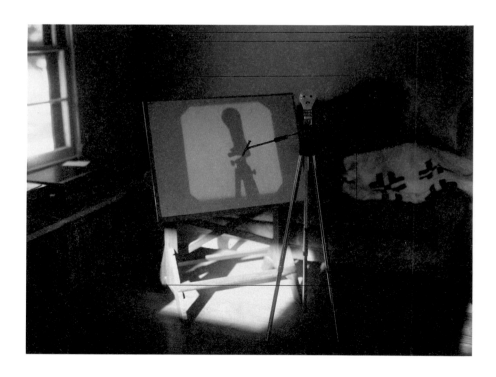

Robert Cumming
Portrait Studio Sketch, 1981

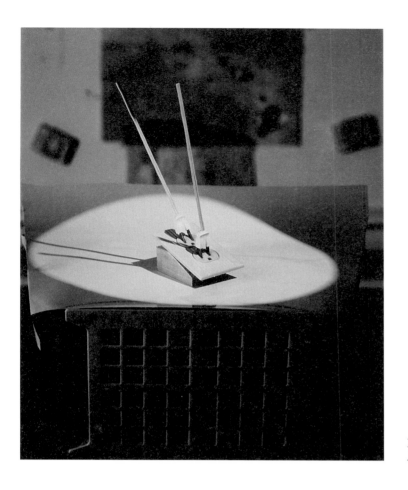

Robert Cumming
Plugs Dining at an Outlet, 1979

Robert Cumming
Graph Showing Bad Business,
1979

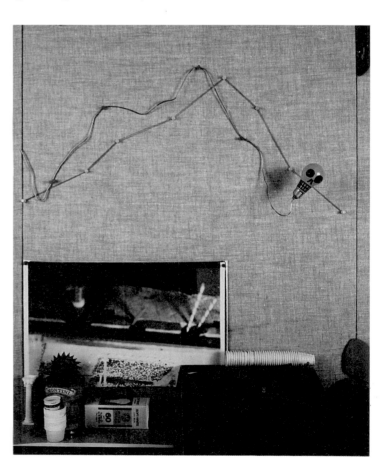

Jan Groover
Untitled, 1980

Jan Groover
Untitled, 1988

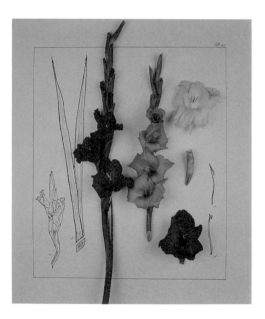 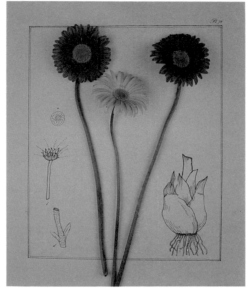

Betty Hahn
Plate 48 (Gladiola), 1988

Betty Hahn
Plate 79 (African Daisy), 1988

Betty Hahn
Tab. 11 Pl. 22 (Stargazer Lily),
1988

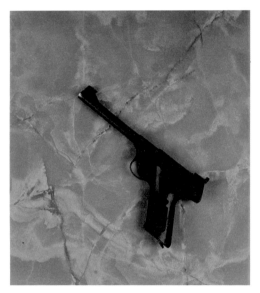 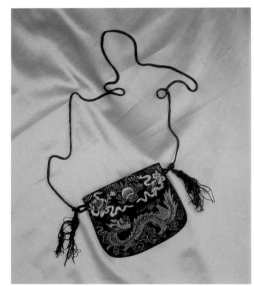

Betty Hahn
Yin and Yang, 1988

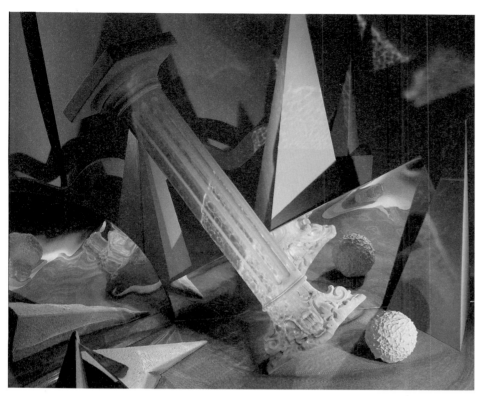

Barbara Kasten
Construct 33, 1986

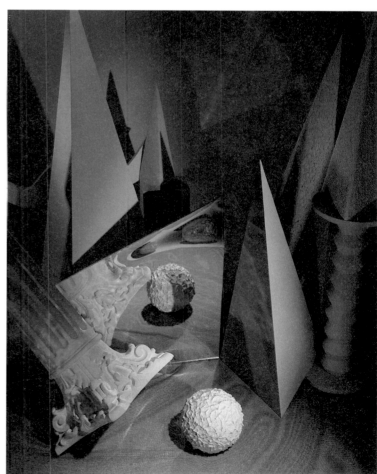

Barbara Kasten
Construct 34, 1986

Frank Majore
The Temptation of St. Anthony,
1984

Frank Majore
Venus, 1986

Frank Majore
Dreamsville, 1986

Sheila Metzner
Dunand Vase, 1983

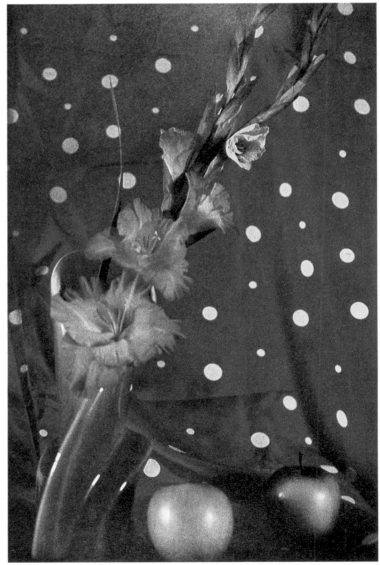

Sheila Metzner
Homage to Man Ray, 1983

Sheila Metzner
Manoukian Vase, 1985

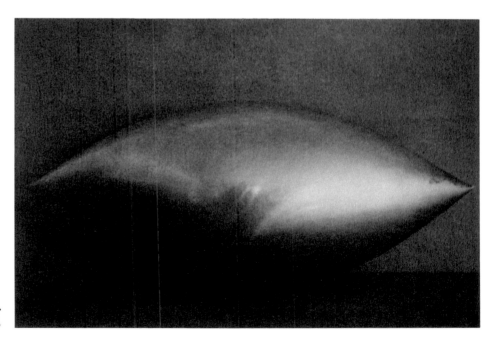

Sheila Metzner
Prototype, 1986

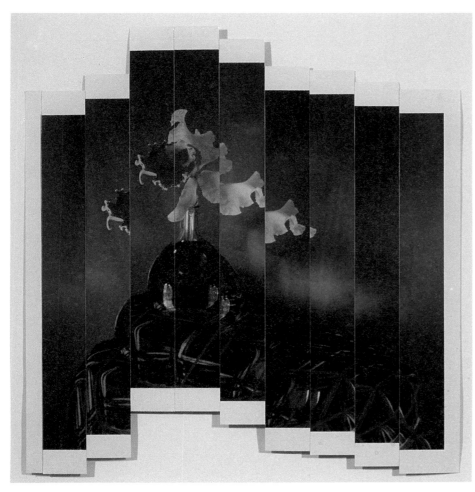

Lucas Samaras
Still Life with Orchid, 1984

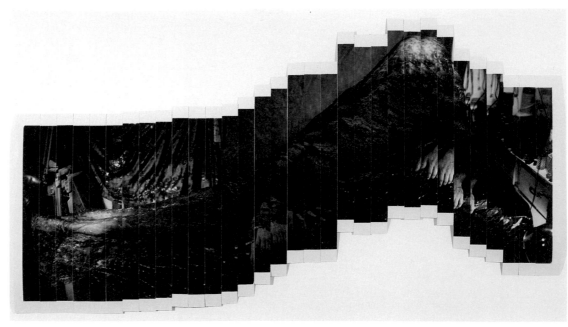

Lucas Samaras
Panorama, 6/22/84

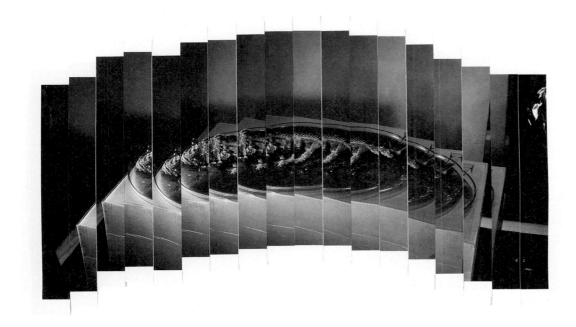

Lucas Samaras
Panorama, 10/9/84

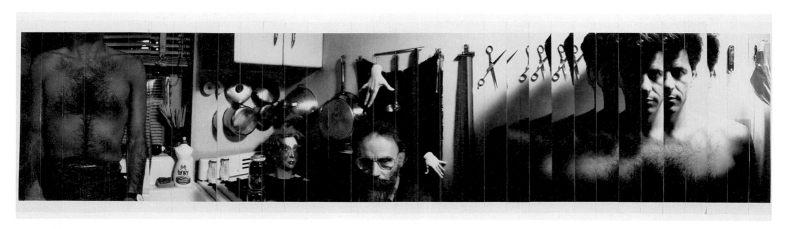

Lucas Samaras
Panorama, 1/17/86

Selected Bibliography

Alinder, James. *Cumming Photographs, Untitled 18.* The Friends of Photography, 1979.

Art News, October, 1985. "New Light on Color", pp 82-91 on Kasten, Parker, and Metzner.

Certain Places, Photographs by William Clift, William Clift Editions, l987.

Champion, Tom. *The Fresson Process,* History of Photography Monograph Series, No. 22, June 1986, School of Art, Arizona State University, Tempe.

Coke, Van Deren with C. DuPont. *Photography: A Facet of Modernism.* New York: Hudson Hills Press, New York, in association with the San Francisco Museum of Modern Art, 1986.

Green, Jonathan. *American Photography A Critical History 1945 to Present,* New York: Harry N. Abrams, 1984.

Grundberg, Andy and Kathleen McCarthy Gauss. *Photography and Art: Interactions Since 1946.* New York: Abbeville Press, 1987.

Heimerdinger, Debra, "Density, Mass and Gravity: Zeke Berman." *re:view,* Newsletter of The Friends of Photography 11:6, June, 1988.

Hoy, Anne H. *Fabrications: Staged, Altered, and Appropriated Photographs.* New York: Abbeville Press, 1987.

Essay by Estelle Jussim. *Constructs: Photographs by Barbara Kasten.* Boston: Little, Brown and Company, 1985.

Kismaric, Susan. *Jan Groover.* New York: Museum of Modern Art, 1987.

Essay by Ben Lifson. *The Photographs of Lucas Samaras, 1969-1986,* New York: Aperture Foundation, 1988.

Lyons, Nathan. *Photography in the Twentieth Century.* New York: Horizon Press in collaboration with George Eastman House, 1967.

Marshall, Richard, Ingrid Sischy, and Richard Howard, *Robert Mapplethorpe.* Boston: Whitney Museum of American Art with Little, Brown and Co., 1988.

Naylor, Colin ed. *Contemporary Photographers.* Chicago, Illinois: St. James Press, 1988.

Parker, Olivia. *Weighing the Planets.* Boston: Little, Brown and Co., 1987.

Rifkin, Ned. *Robert Cumming Intuitive Inventions.* Smithsonian Institution, Hirshhorn Museum and Sculpture Garden, 1988.

Schapiro, Meyer, "The Apples of Cezanne: An Essay on the Meaning of Still-Life" (1968), in his *Modern Art: 19th and 20th Centuries Selected Papers.* New York: Braziller, 1978, pp. 1-45.

Sullivan, Constance. *Legacy of Light.* New York: Alfred A. Knopf, 1987.

Szarkowski, John. *Irving Penn.* Boston: Museum of Modern Art, New York Graphic Society with Little, Brown and Co., 1984.

Watkins, Lee and Barbara London. *The Photograph Collector's Guide.* Boston: New York Graphic Society, 1979.

Essay by Tom Wolfe. *Marie Cosindas Color Photographs.* Boston: Little, Brown and Co., 1978.

Exhibition Checklist

In dimensions given,
height precedes width

Zeke Berman (American, b. 1951)
1. *Untitled*, 1987
16×20″
Silver gelatin print
Edition of 25
Lent by Lieberman & Saul Gallery, New York

2. *Untitled,* 1985
20×16″
Silver gelatin print
Edition of 25
Lent by Lieberman & Saul Gallery. New York

3. *Untitled,* 1984
16×20″
Silver gelatin print
Edition of 25
Private collection, St. Louis

Clegg and Guttmann
(both, American b. Israel, 1957)
4. *Sunkist Lemons (with a Tea Strainer),* 1987
30×39″
Cibachrome
Lent by Mr. and Mrs. Alfred Glazier, courtesy
Jay Gorney Modern Art, New York

5. *TABA-BASCO,* 1985
12½×16″
Cibachrome
Lent by Mr. R. Mayer, courtesy
Jay Gorney Modern Art, New York

William Clift (American, b. 1944)
6. *Portrait #6, Juan Hamilton Sculpture,*
Fragment X O, 1983
5¾×7¼″
Silver gelatin print
Lent by Mr. and Mrs. Jack Chasnoff
©William Clift, 1983

7. *Portrait #2, Juan Hamilton Sculpture,* 1981
8⅜×6⁹⁄₁₆″
Silver gelatin print
Lent by the photographer ©William Clift, 1981

8. *Barbara's Table,* Boston, 1956
2⅞×2⅛″
Offset reproduction from original Polaroid Type 32
Lent by the photographer ©William Clift, 1987

Marie Cosindas (American)
9. *Baby's Breath Bouquet,* 1976
14½×11″
Color dye transfer print
Lent by The Art Institute of Chicago, Restricted
Gift of Society for Contemporary Art, 1979

10. *Japanese Floral,* 1982
14 × 11″
Dye transfer print
Lent by the photographer

11. *William Powell Still Life,* 1985
7×5″
Type C Print
Lent by the photographer

Robert Cumming (American, b. 1943)
12. *Exploding Paintbrush,* 1975
2 panels, each 9¹⁵⁄₁₆×7¾″
Silver gelatin print
Lent by The Art Institute of Chicago, Gift of
Temmie and Albert Gilbert, 1983
© 1988 The Art Institute of Chicago.
All rights reserved.

13. *Portrait Studio Sketch,* 1981
8½×11″
Color Polaroid
Lent by Castelli Graphics, New York

14. *Plugs Dining at an Outlet,* 1979
28⅝×22″
Large format Polaroid
Lent by Castelli Graphics, New York

15. *Graph Showing Bad Business,* 1979
28⅝×22″
Large format Polaroid
Lent by Castelli Graphics,
New York

Jan Groover (American, b. 1943)
16. *Untitled,* 1980
16×20″
Type C Print
Lent by Robert Miller Gallery, New York

17. *Untitled,* 1982
8×10″
Platinum print
Lent by Robert Miller Gallery, New York

18. *Untitled,* 1988
16×20″
Type C Print
Lent by Robert Miller Gallery, New York

Betty Hahn (American, b. 1940)
19. *Plate 48 (Gladiola),* 1988
24×20″
Color Polaroid
Lent by Andrew Smith Gallery, Santa Fe

20. *Plate 79 (African Daisy),* 1988
24×20″
Color Polaroid
Lent by Andrew Smith Gallery, Santa Fe

21. *Tab. 11 Pl. 22 (Stargazer Lily),* 1988
24×20″
Color Polaroid
Lent by Andrew Smith Gallery, Santa Fe

22. *Yin and Yang,* 1988
3 panels, each 24×20″
Color Polaroid
Lent by Andrew Smith Gallery, Santa Fe

Barbara Kasten (American, b. 1936)
23. *Construct 33,* 1986
30×40″
Cibachrome
Lent by John Weber Gallery, New York

24. *Construct 34,* 1986
40×30″
Cibachrome
Lent by John Weber Gallery, New York

Frank Majore (American, b. 1946)
25. *The Temptation of St. Anthony,* 1984
20×24″
Cibachrome, edition of 5
Lent by the photographer

26. *Venus,* 1986
24×20″
Cibachrome, edition of 5
Lent by Holly Solomon Gallery, New York

27. *Dreamsville,* 1986
48×60″
Cibachrome, edition of 3
Private Collection, New York

Robert Mapplethorpe (American, b. 1946)
28. *Untitled,* c. 1982
21¾×17¾″
Edition 15/40
Photogravure
Lent by Bonni Benrubi Fine Arts, New York

29. *Calla Lily,* 1986
24×20″
Silver gelatin print
Lent by Robert Miller Gallery, New York

30. *Orchid,* 1986
24×20″
Silver gelatin print
Lent by Robert Miller Gallery, New York

31. *Irises,* 1986
24×20″
Silver gelatin print
Lent by Robert Miller Gallery, New York

Sheila Metzner (American, b. 1939)
32. *Dunand Vase,* 1983
19¼×13″
Michel Fresson Print
Lent by Shelia and Jeffrey Metzner

33. *Homage to Man Ray,* 1983
19¼×13″
Michel Fresson Print
Lent by Shelia and Jeffrey Metzner

34. *Manoukian Vase,* 1985
19¼×13″
Michel Fresson Print
Lent by Shelia and Jeffrey Metzner

35. *Prototype,* 1986
10¾×16½″
Michel Fresson Print
Lent by Shelia and Jeffrey Metzner

Olivia Parker (American, b. 1941)
36. *Carrousel,* 1982
12×20″
Selenium split-toned contact print
Lent by Brent Sikkima/Vision Gallery, Boston

37. *Statue Seen by Man and Observed
 by a Pigeon,* 1984
14×11″
Selenium split-toned contact print
Lent by Brent Sikkima/Vision Gallery, Boston

38. *Weighing the Planets,* 1984
11 × 14″
Selenium split-toned contact print
Lent by Brent Sikkima/Vision Gallery, Boston

39. *Site II, Deer,* 1981
8 × 10″
Selenium split-toned contact print
Lent by Brent Sikkima/Vision Gallery, Boston

Irving Penn (American, b. 1917)
40. *The Spilled Cream, New York,* 1980
11½ × 19⅜″
Platinum/Palladium Print
Lent by Pace/MacGill Gallery, New York ©The artist

41. *Camel Pack, New York,* 1975
30 × 22″
Platinum/Palladium Print
Lent by Pace/MacGill Gallery, New York ©The artist

42. *Blast, New York,* 1980
11 1/16 × 19¼″
Platinum/Palladium Print
Lent by Pace/MacGill Gallery, New York ©The artist

Lucas Samaras (American, b. Greece, 1936)
43. *Still Life with Orchid,* 1984
12¼ × 13″
Unique Polacolor II Assemblage
Lent by Goldman, Sachs & Co., New York ©The artist

44. *Panorama,* 6/22/84
16¼ × 29″
Unique Polacolor II Assemblage
Lent by Pace/MacGill Gallery, New York ©The artist

45. *Panorama,* 10/9/84
13 × 23½″
Unique Polacolor II Assemblage
Lent by Pace/MacGill Gallery, New York ©The artist

46. *Panorama,* 1/17/86
11 × 43¼″
Unique Polacolor II Assemblage
Lent by Pace/MacGill Gallery, New York ©The artist

Editing: Lois M. Engfehr
Design: Lisa E. Payne-Naeger
Production Art: Lisa E. Payne-Naeger
Composition: kan-Type, Inc.
Type: ITC Caslon
Reproductions: 200 line halftones, 4 color separations
Paper: Cover: 75# cover, Chromolux Metallic Gray Pearl
 Text: 80# text Karma, Matte, Bright white
 Cover: White Foil Stamped and Blind Embossed
Number of Editions: 1,000
Printing & Stamping: Marlo Graphics Inc.
Binding: Wrap Ups (perfect bound)